All Photography by Paul Postle
Taken between March 1994 and June 1995
Words by Blur
Text edited by Andy Ross
Designed by Stylorouge, London

We're going on a kind of tour...only a year late
I need to go to the loo...Here we go...

HarperCollins*Publishers*
77–85 Fulham Palace Road,
Hammersmith, London W6 8JB

A Paperback Original 1995
9 8 7 0 5 4 3 2 1

Copyright © Paul Postle & Blur 1995

The Author asserts the moral right to
be identified as the author of this work

A catalogue record for this book
is available from the British Library

ISBN 0 00 638748 9

Printed in Italy by Rotolito Lombarda S.p.A.

Extra special thanks to Joe & Jenny, all at CMO, Ifan & the
crew, Terry at Tapestry, and all the people, so many people.

blurb

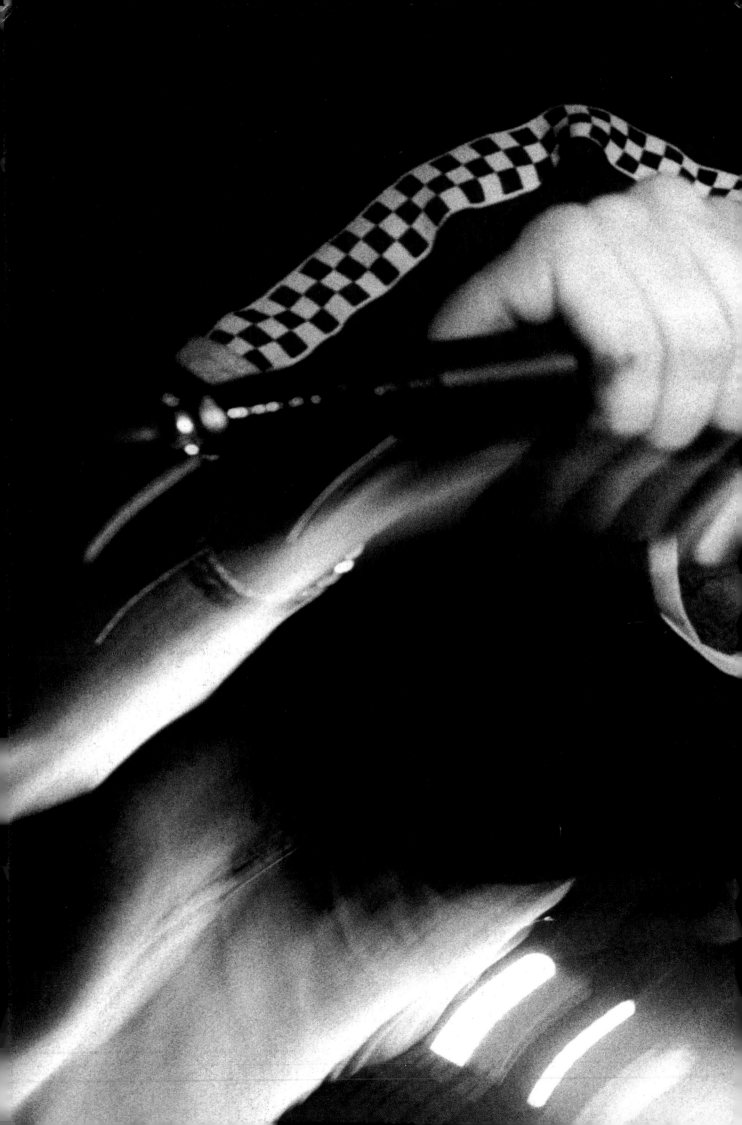

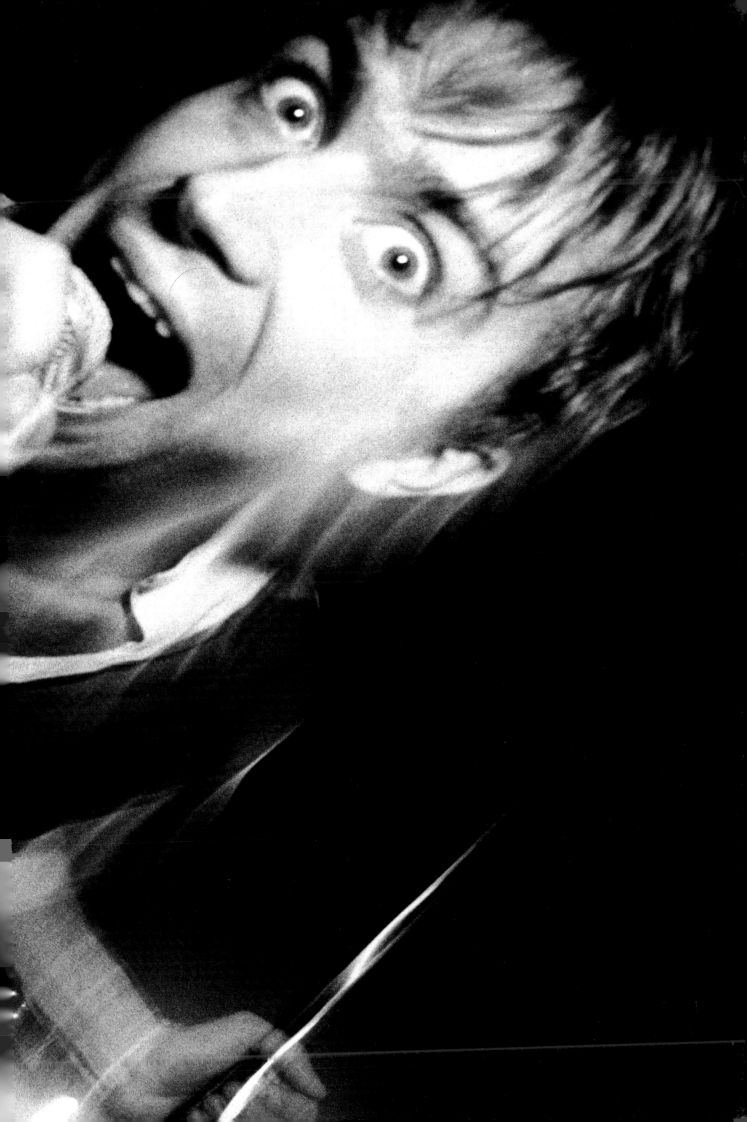

LET'S
ALL 'A
DISCO

VE A

The publisher was most concerned that in some way
we made it known that this is an official Blurbook...
Well, this is an official Blurbook.
It's a look at the good and the bad hangovers of the
Parklife year that started in April 1994 at Walthamstow,
and ended in the rain at Mile End in June 1995.
If you were there at any point...Cheers

damon
pop person

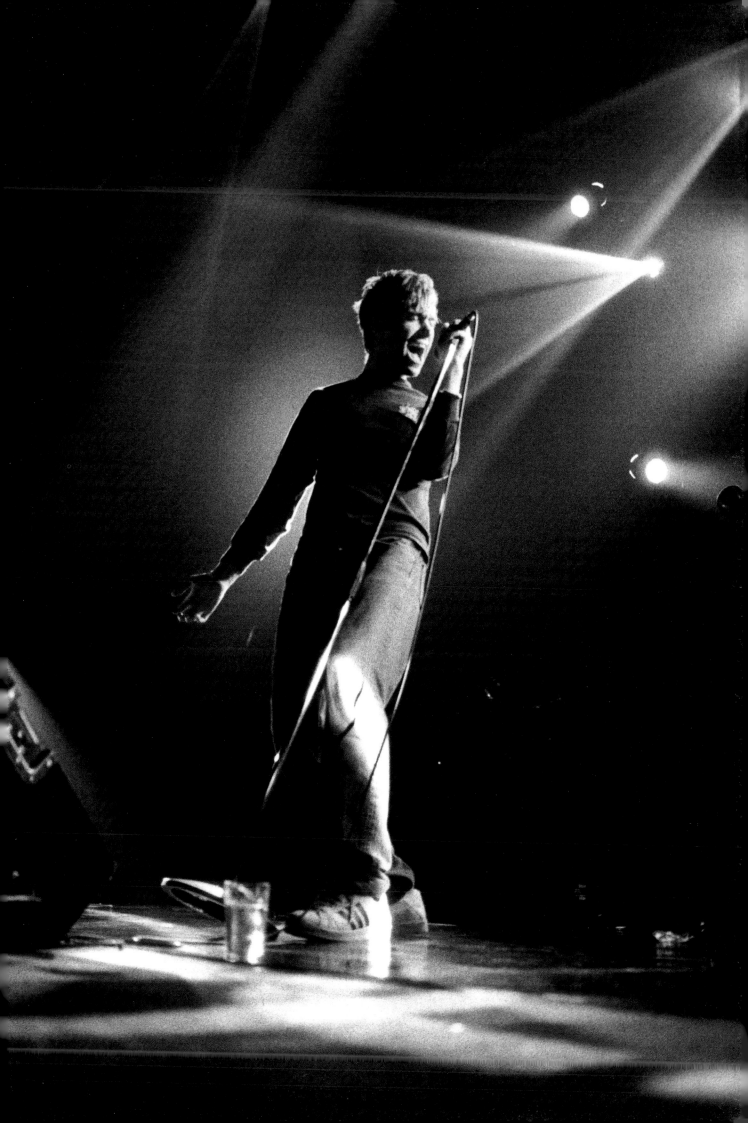

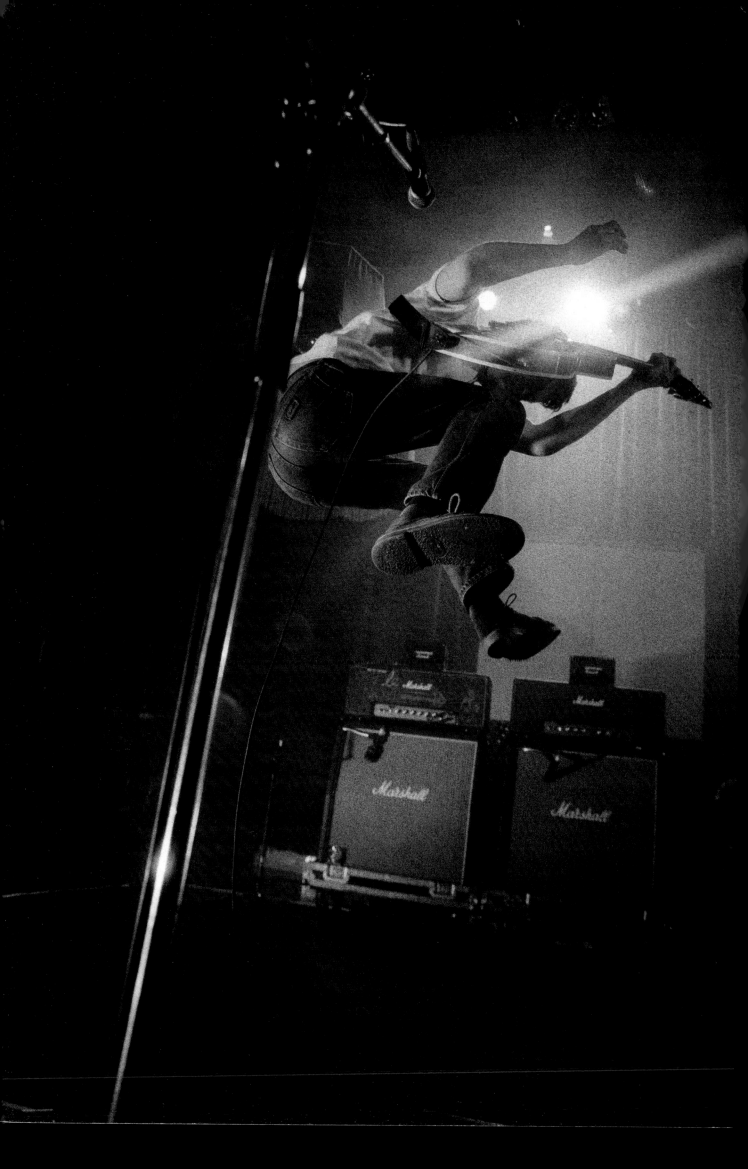

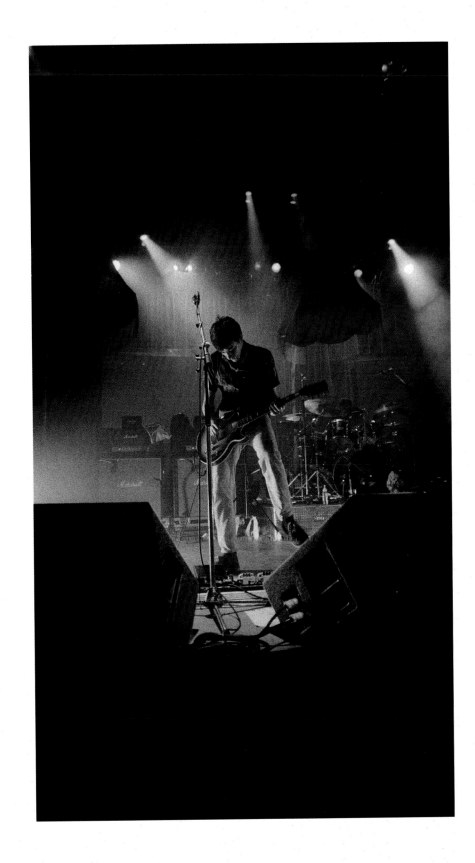

GRAHAM: There's the devil…in sandshoes…they're from Curtess.
They're me Wranglers I got from Archway Menswear shop. The original meaning of menswear which is a shop that sells clothes for men.

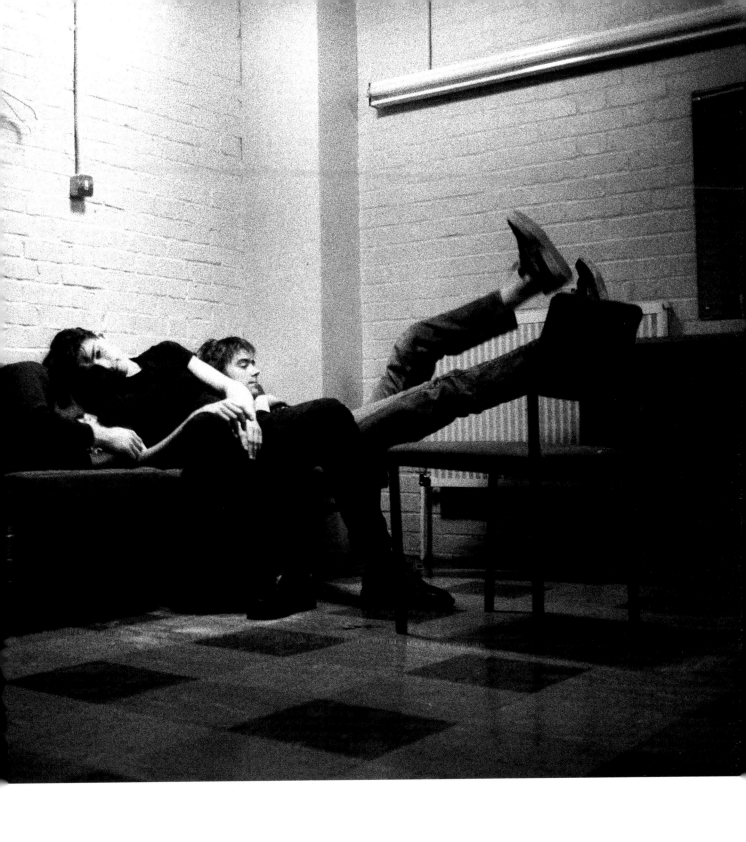

MAY 16th 1994 *Glasgow*

DAMON: That's the bird lying on the bed and Alex saying 'I'm going to have a shower now'.

DAMON: We all remember Glasgow - one of the only two occasions where we've been charged money for trashing hotel rooms...not bad for six years.

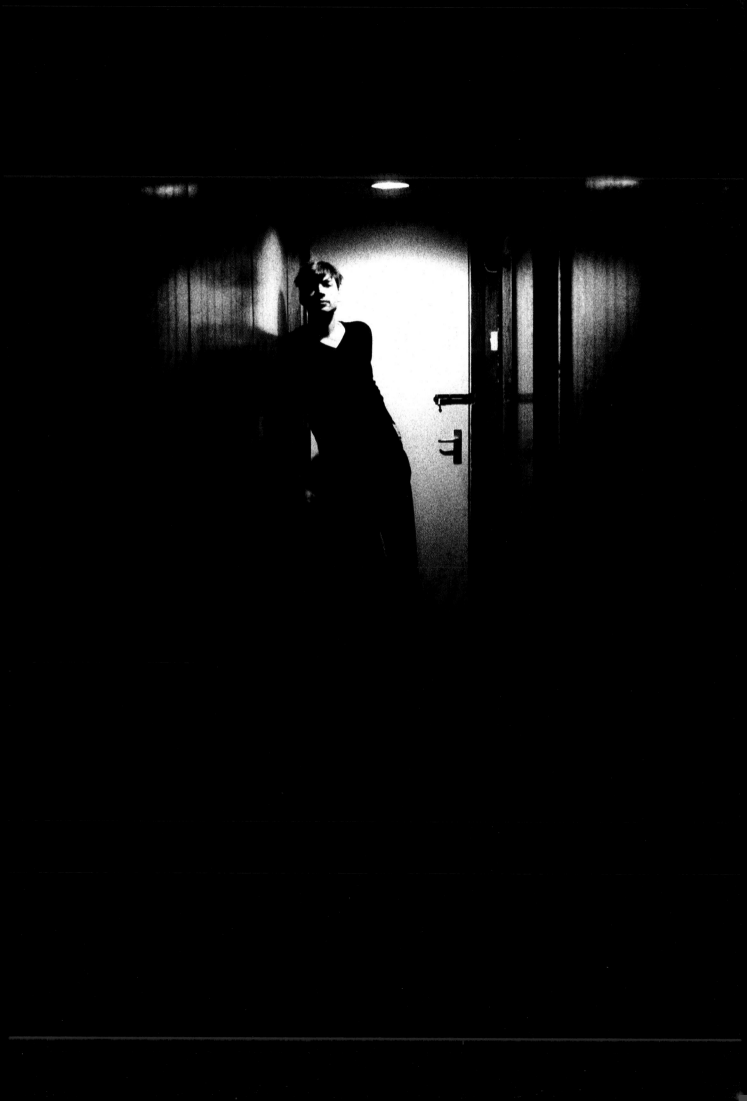

ALEX: My hangover won five Brits.

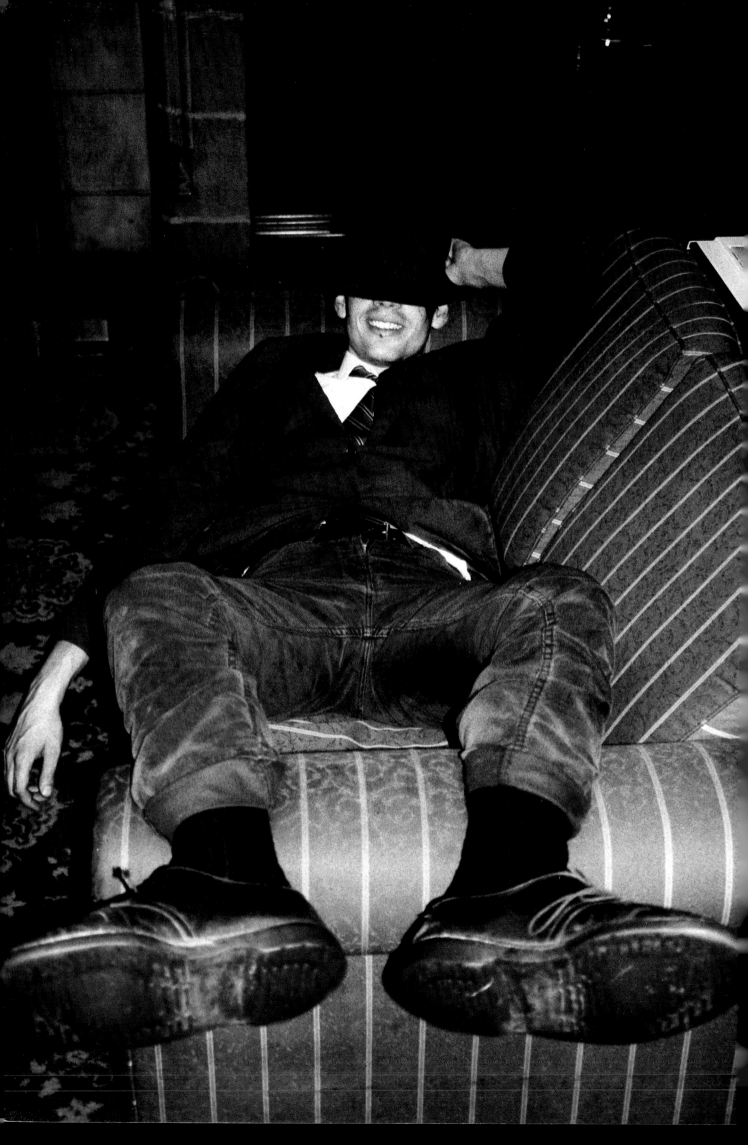

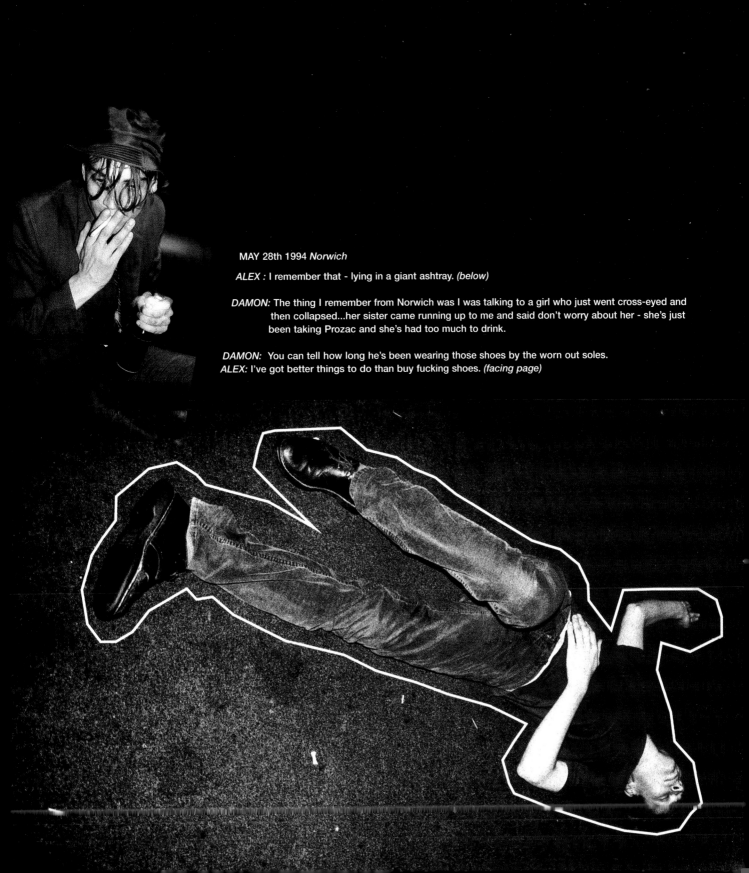

MAY 28th 1994 *Norwich*

ALEX : I remember that - lying in a giant ashtray. *(below)*

DAMON: The thing I remember from Norwich was I was talking to a girl who just went cross-eyed and then collapsed...her sister came running up to me and said don't worry about her - she's just been taking Prozac and she's had too much to drink.

DAMON: You can tell how long he's been wearing those shoes by the worn out soles.
ALEX: I've got better things to do than buy fucking shoes. *(facing page)*

QUALITY CONTROL

Blurred out of focus prints

*Camera shake - hold camera steady

*Focusing error - applies to variable focus cameras

*Subject too close - allow 2 metre distance for fixed focus cameras

*Dirt or condensation on lens

ADVICE LABEL

LIFT & PEEL HERE

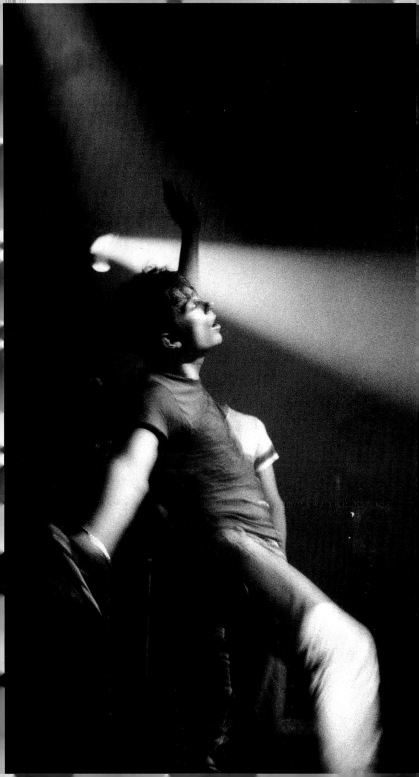

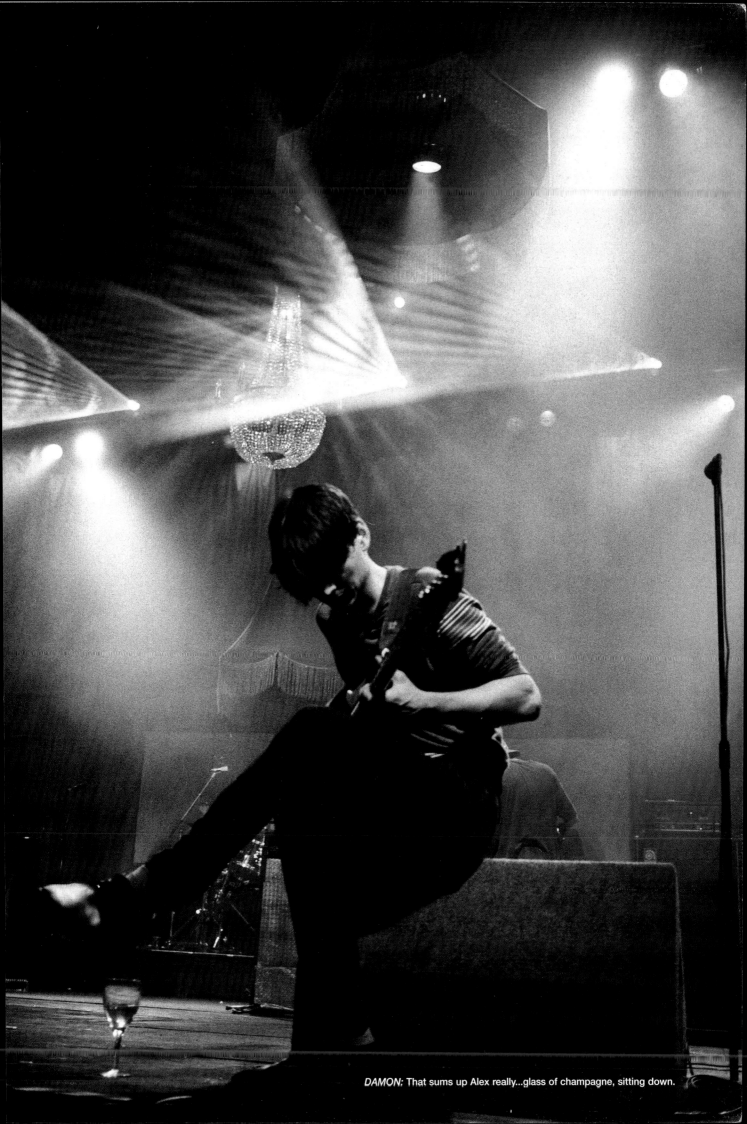

DAMON: That sums up Alex really...glass of champagne, sitting down.

Aylesbury

DAMON: That photo could have been taken any time over the last six years.
My mum painted a backdrop exactly like that, now we have to pay £25,000 for the same thing.

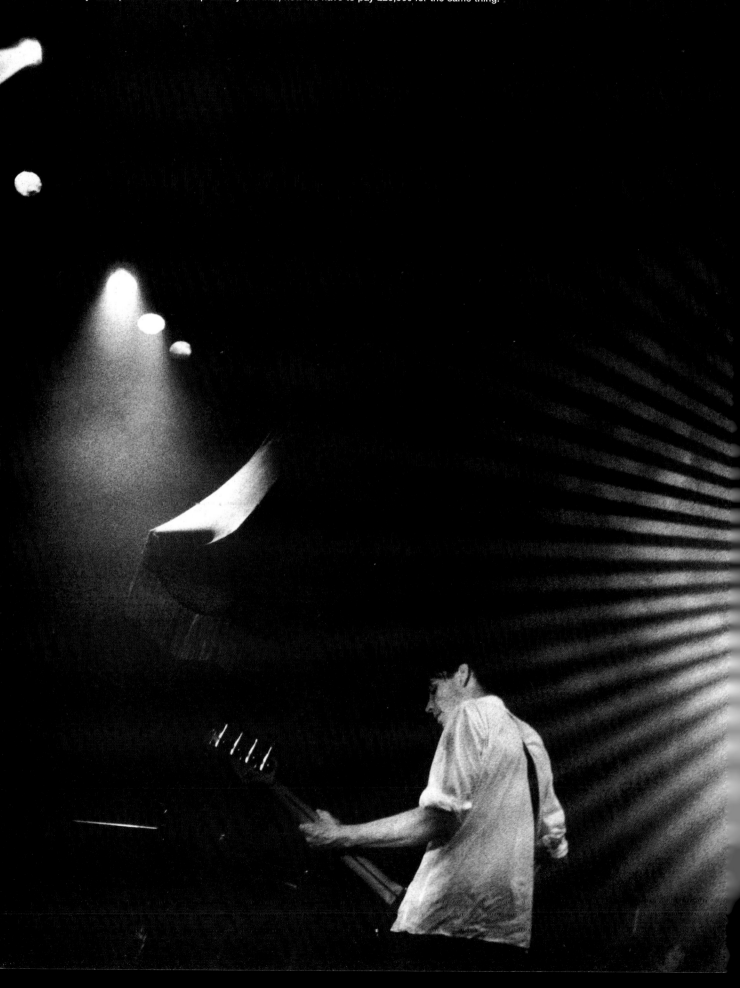

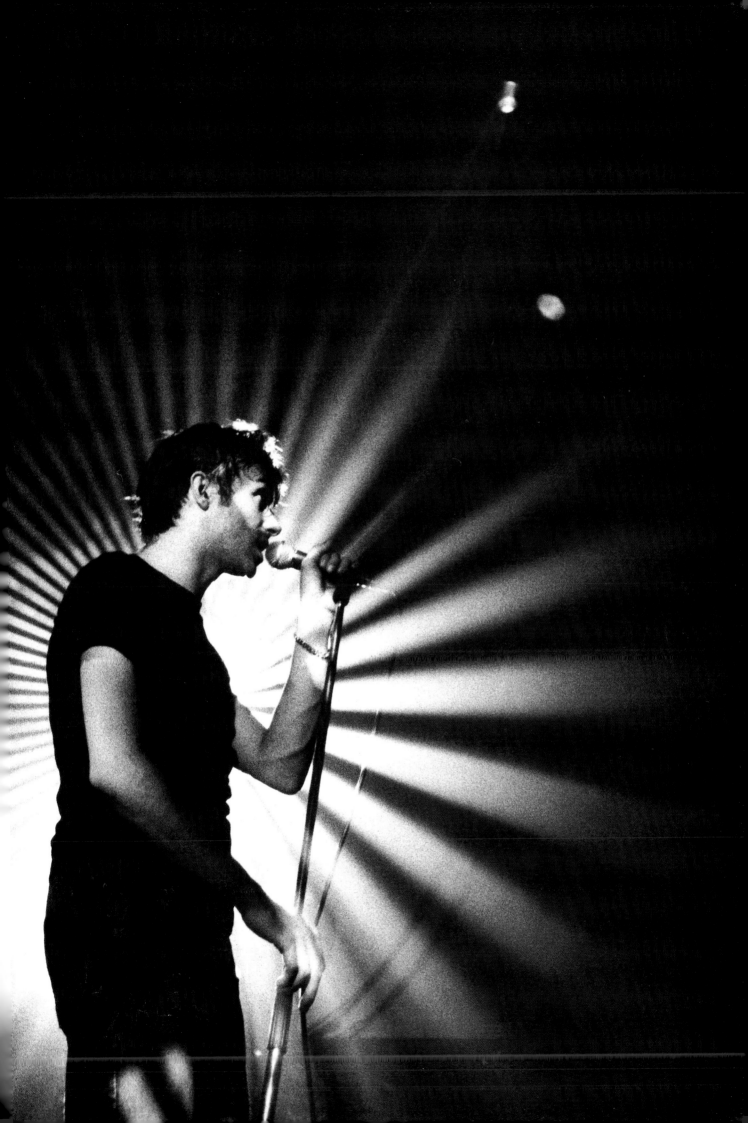

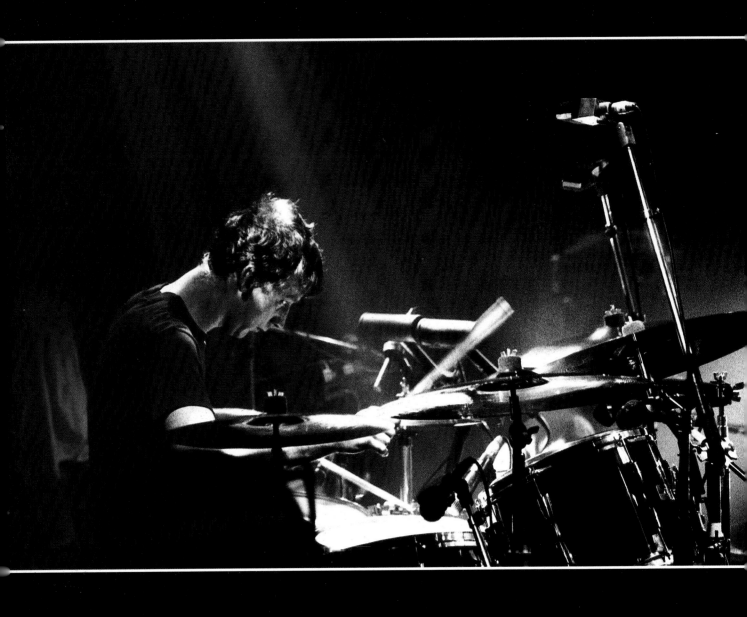

DAMON: When I was about 15, Graham told me about a dream he'd had where he was asleep and Keith Moon had come and sat at the bottom of the bed and I knew from that moment that Graham would be in a band with me. The irony of it is that I can't stand him when he's like that.

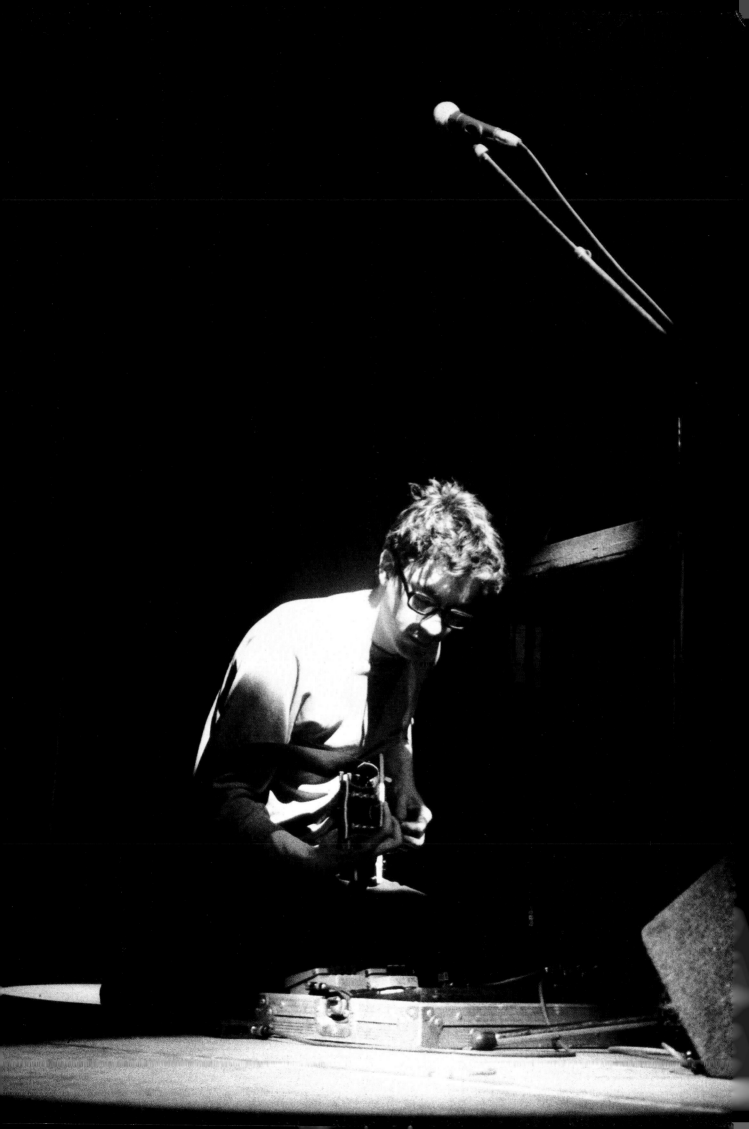

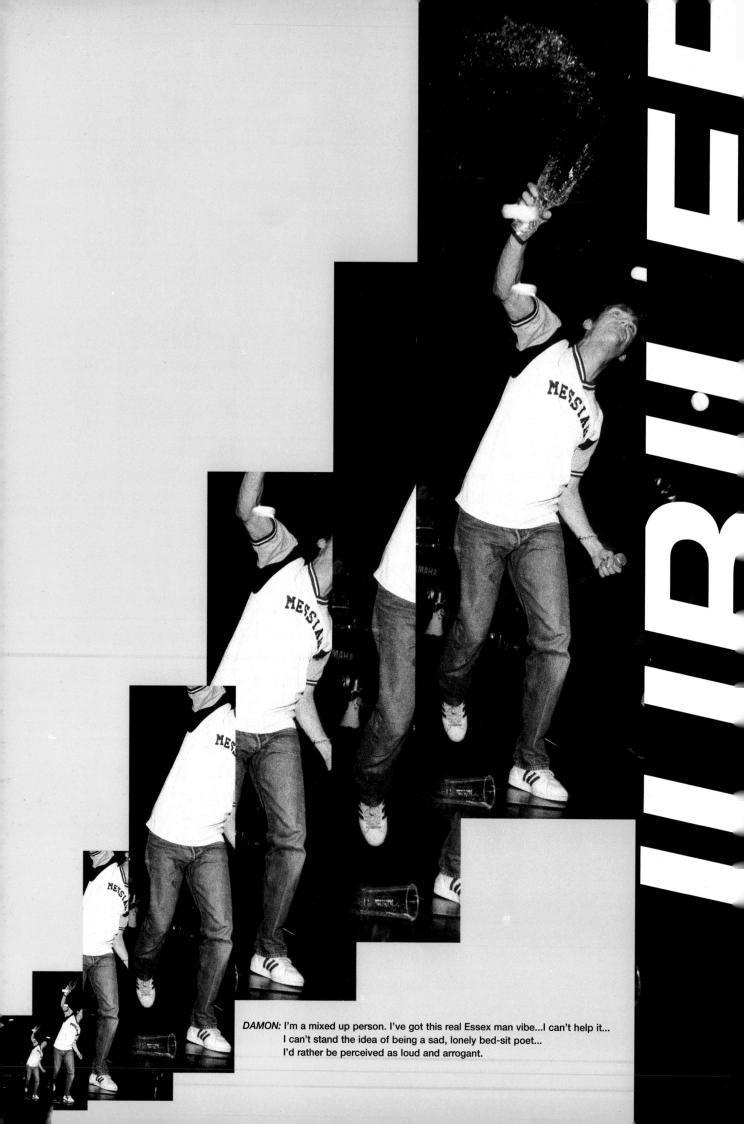

DAMON: I'm a mixed up person. I've got this real Essex man vibe...I can't help it...
I can't stand the idea of being a sad, lonely bed-sit poet...
I'd rather be perceived as loud and arrogant.

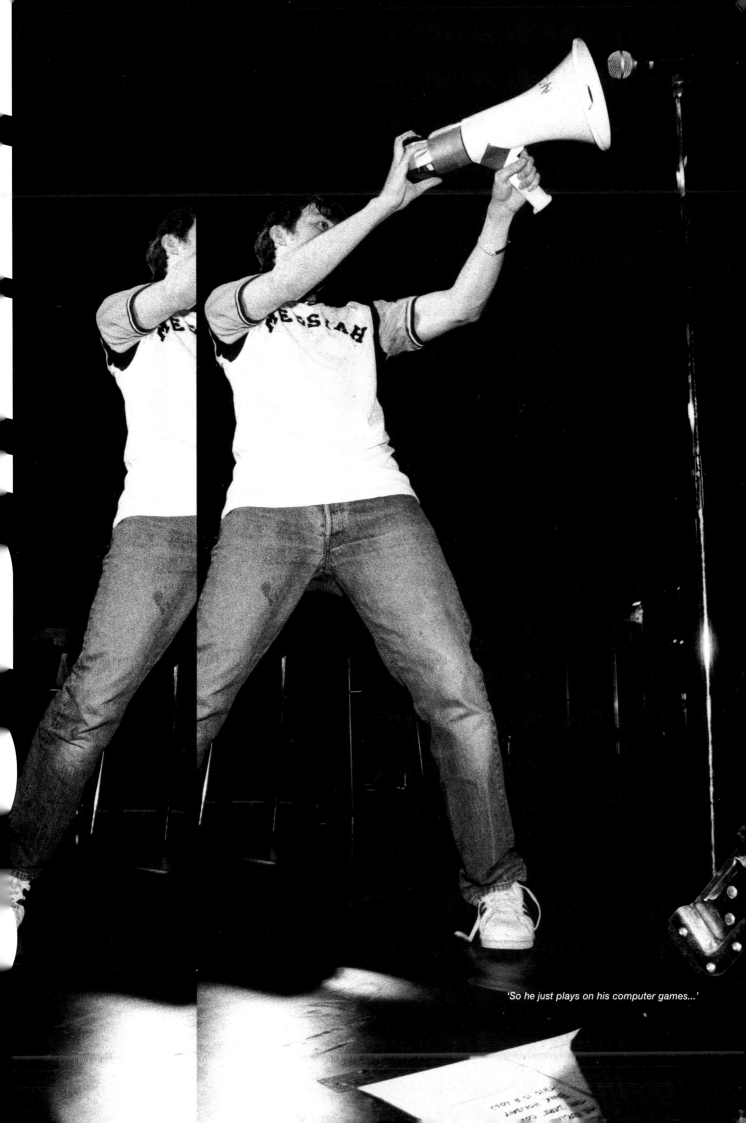

'So he just plays on his computer games...'

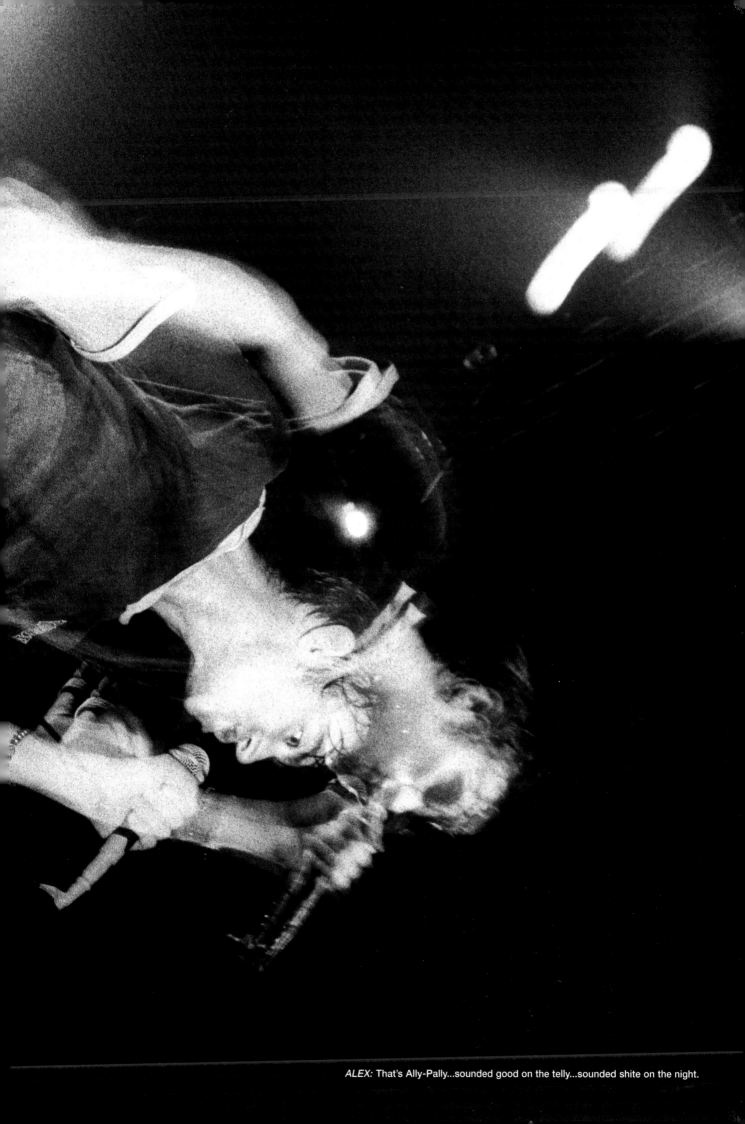

ALEX: That's Ally-Pally...sounded good on the telly...sounded shite on the night.

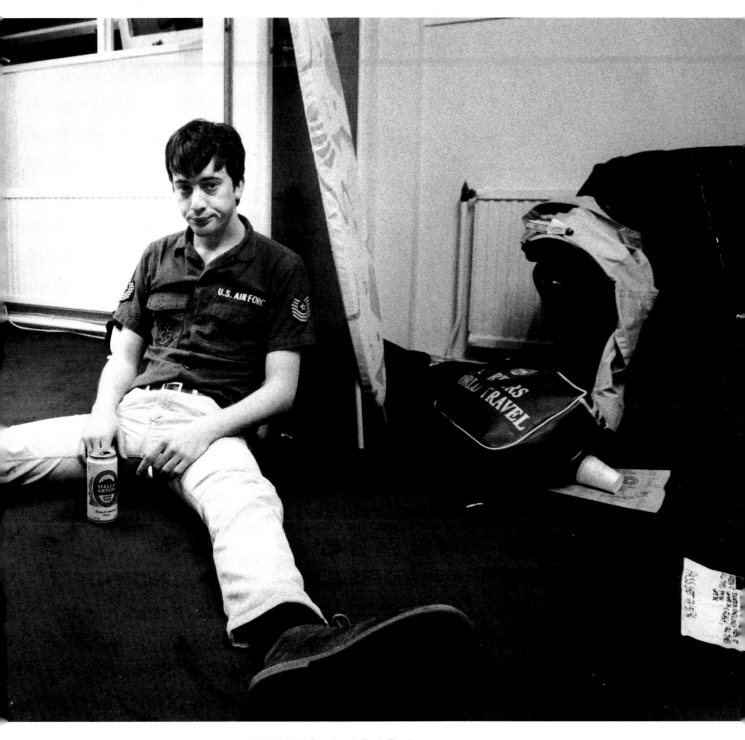

MAY 26 1994 *Shepherds Bush Empire*
GRAHAM: I lose a lot of weight when I come off tour coz I don't know how to look after myself
anymore and I don't eat. You're just pampered and looked after, aren't you?

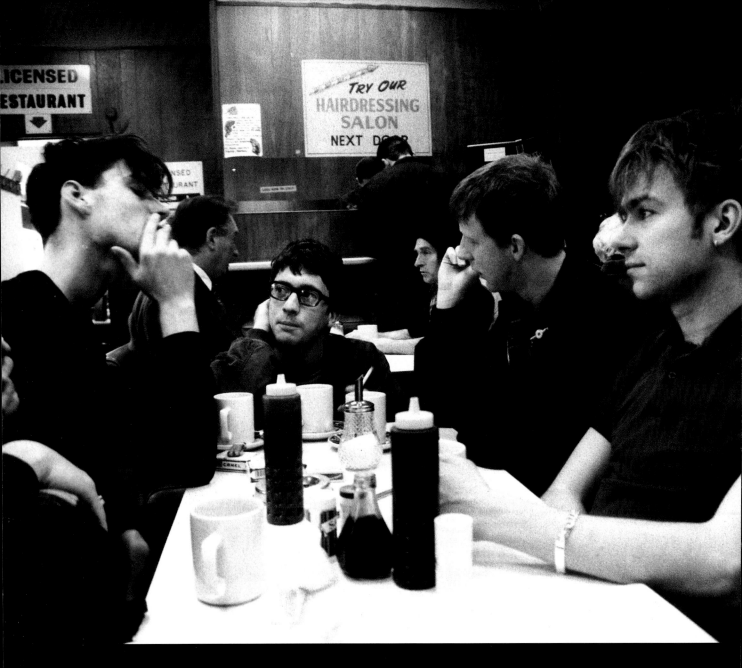

DAMON: We have one rule and that's basically 'don't drink before you play a gig'.
Don't ever do anything before you do what you've got to do.

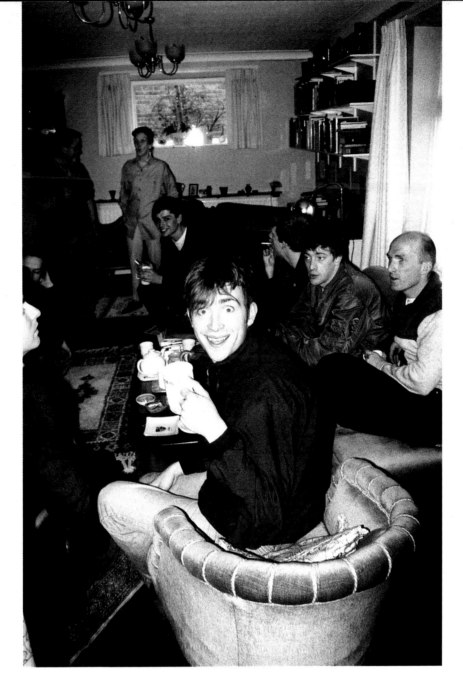

DAMON: That's round our tour manager's parents' house in Pontefract having a cup of tea.
ALEX: She makes a lovely fruit cake.
DAMON: She *does* make a lovely fruit cake.

GRAHAM: We spend a lot of time sitting in cafes drinking tea.
We like cake and tea...

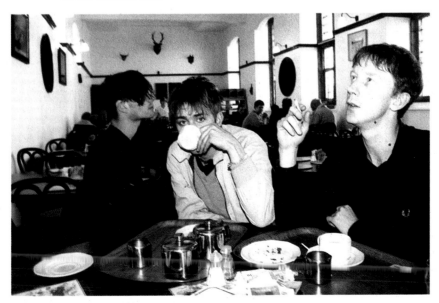

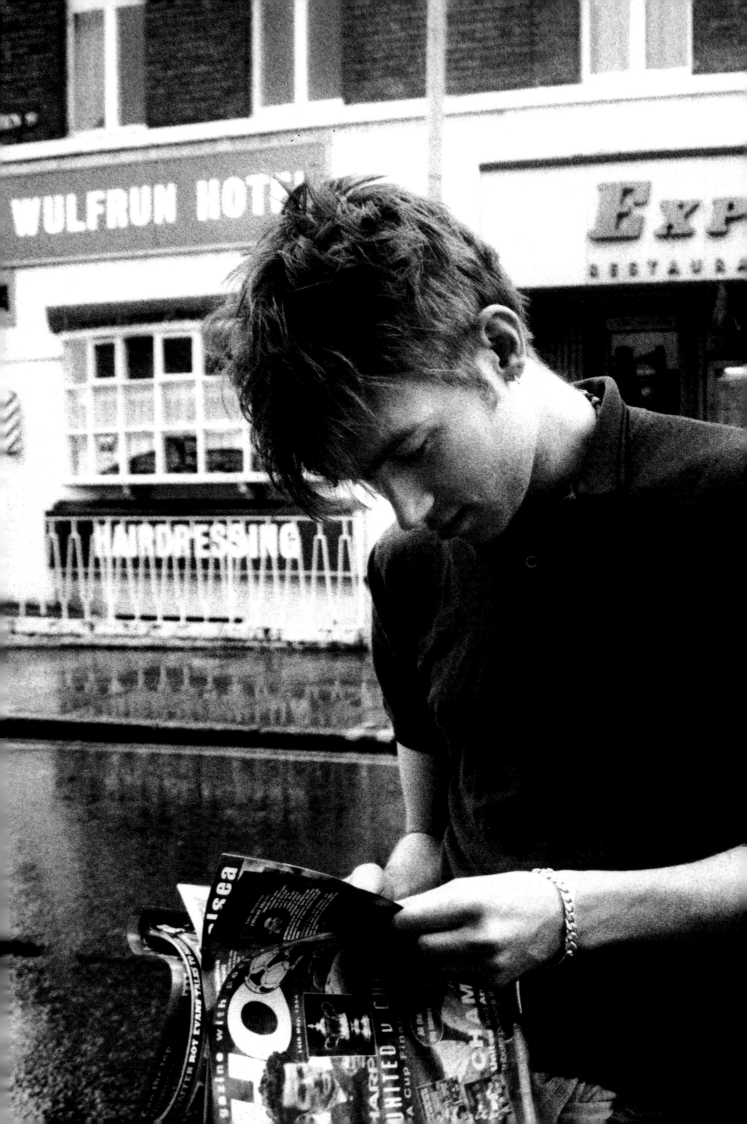

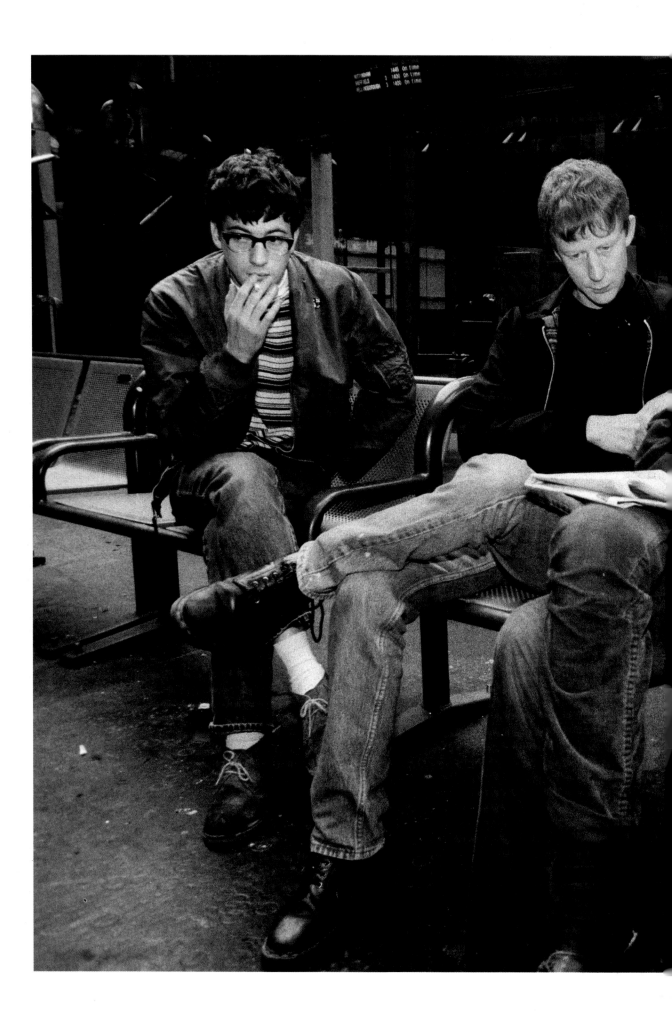

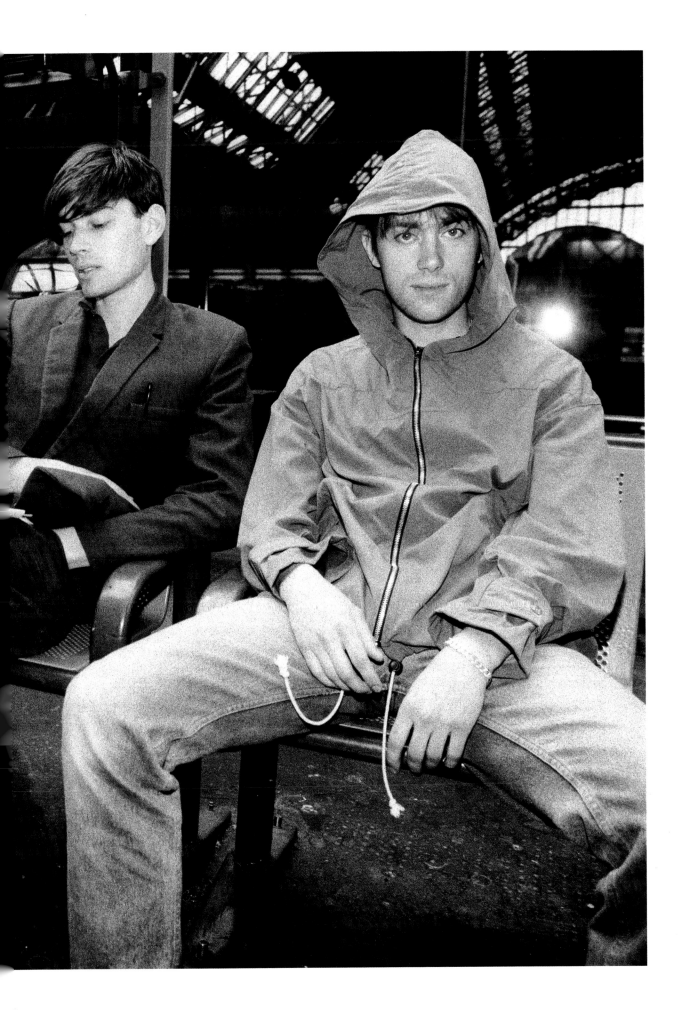

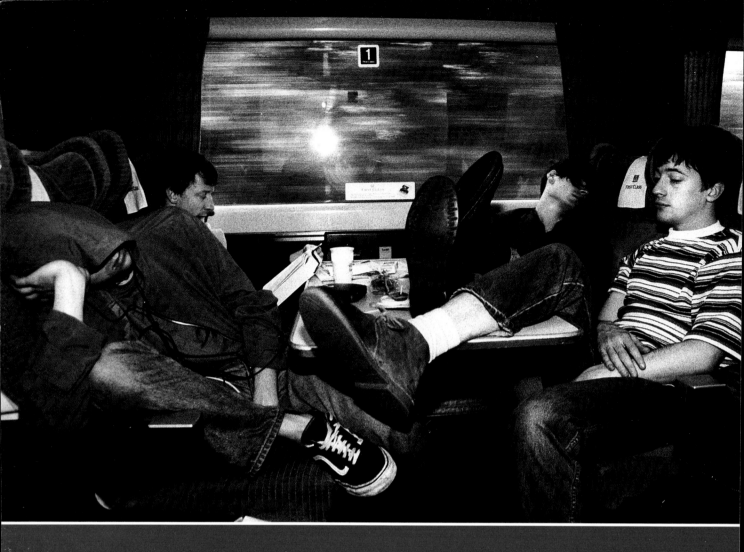

DAMON: We're on the train because the coach broke down and we're not in first class - it's just a sticker we put there.

13:24 Newcastle

DAVE: (right) You can't take a good picture of a drummer with a drum kit.

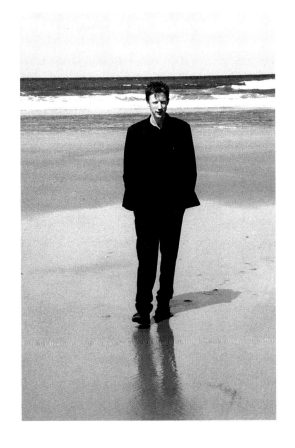

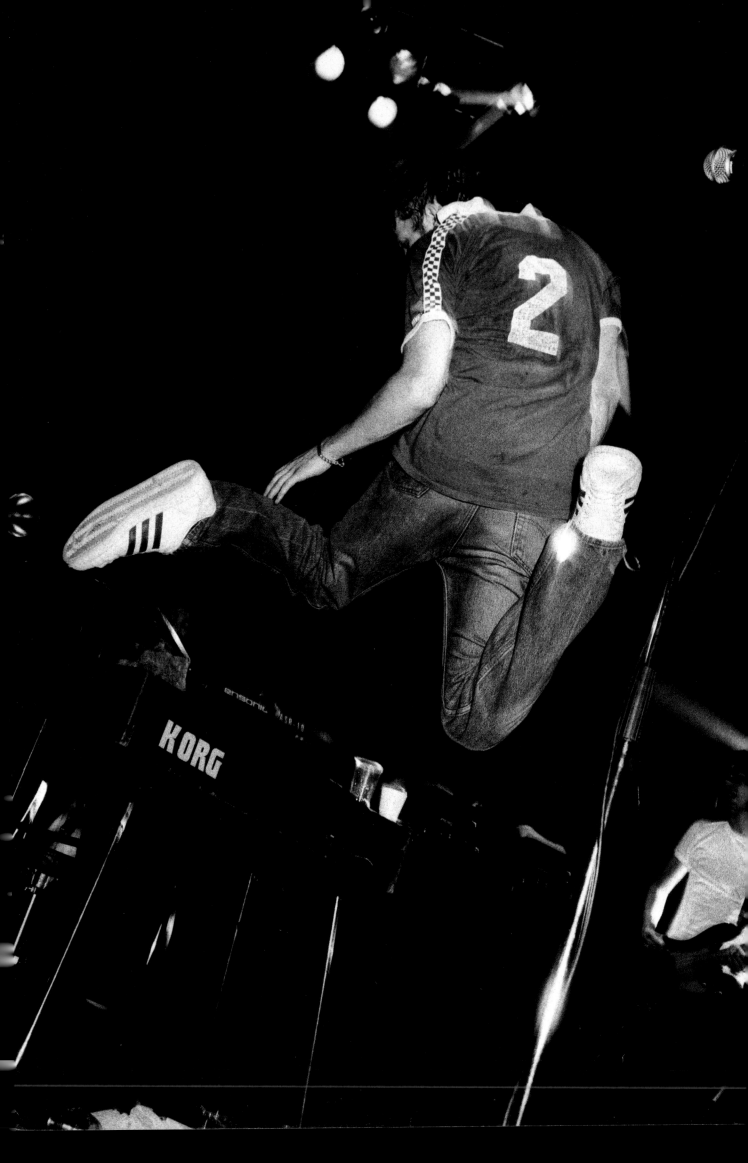

DAMON: I managed to dislocate both my fuckin' legs there

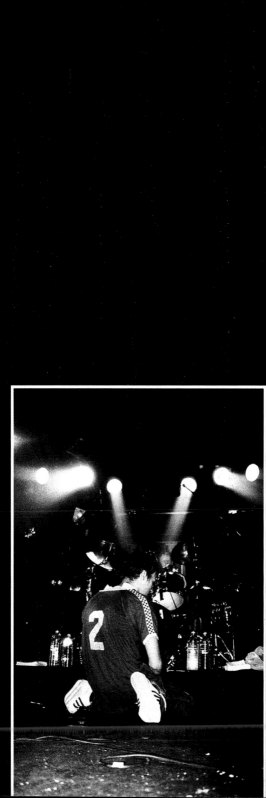

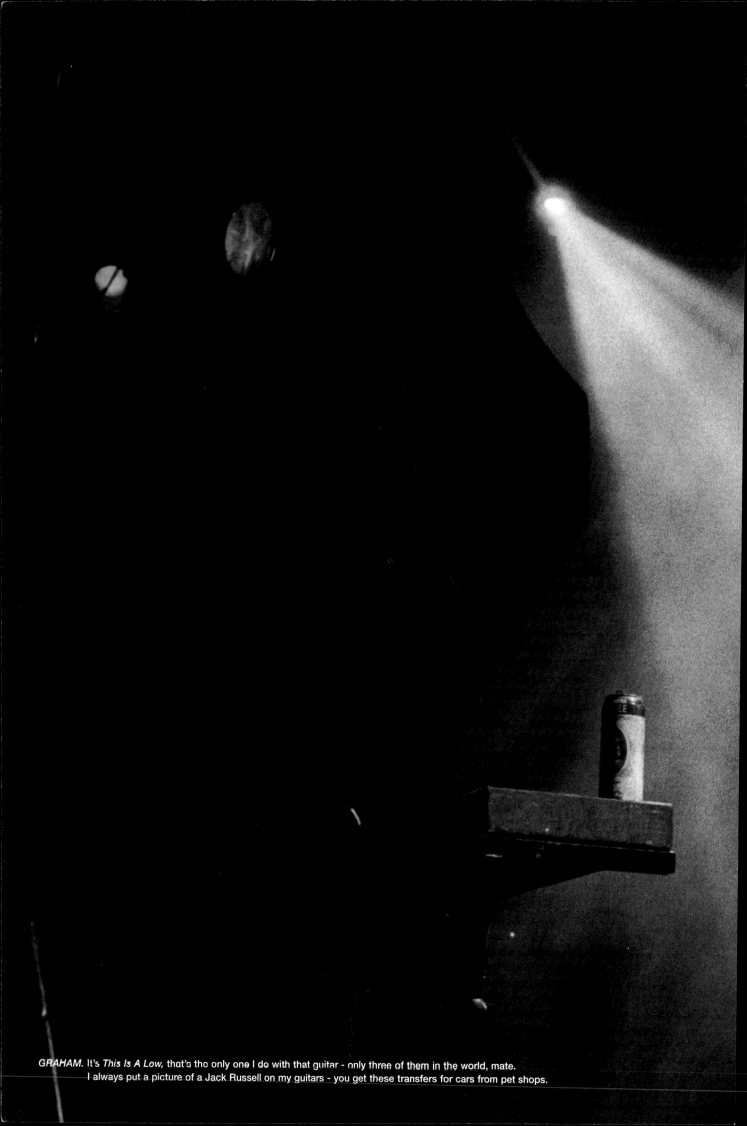

GRAHAM. It's *This Is A Low,* that's the only one I do with that guitar - only three of them in the world, mate.
I always put a picture of a Jack Russell on my guitars - you get these transfers for cars from pet shops.

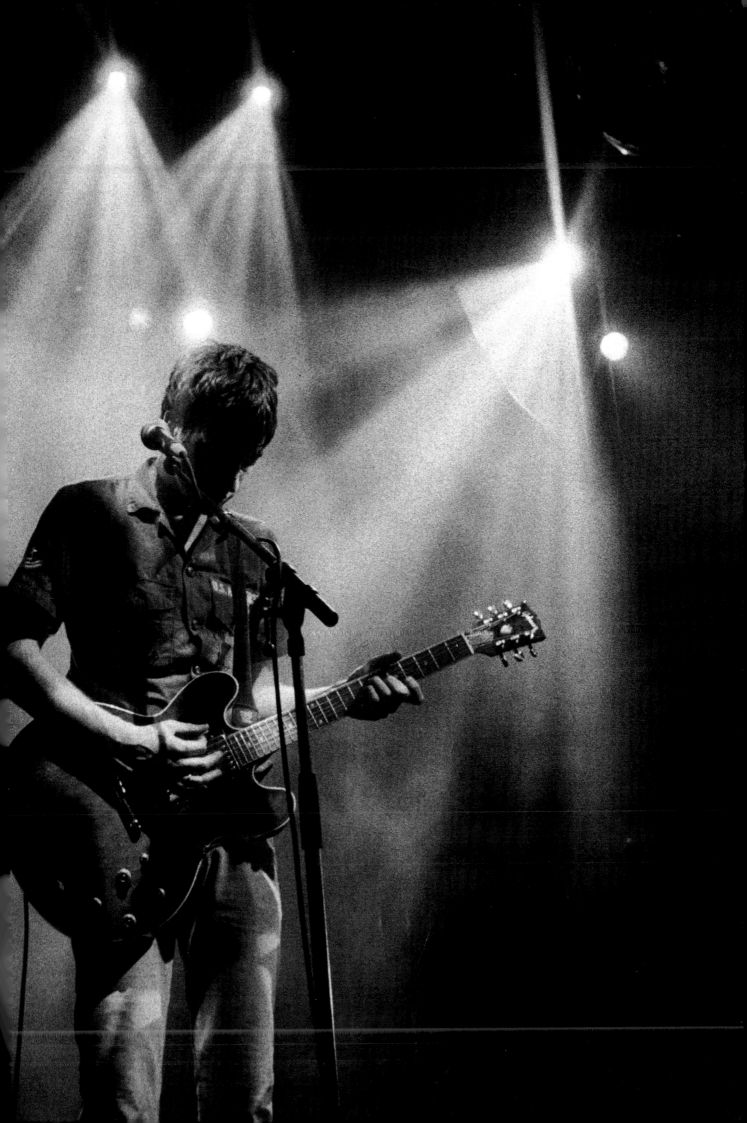

HULL

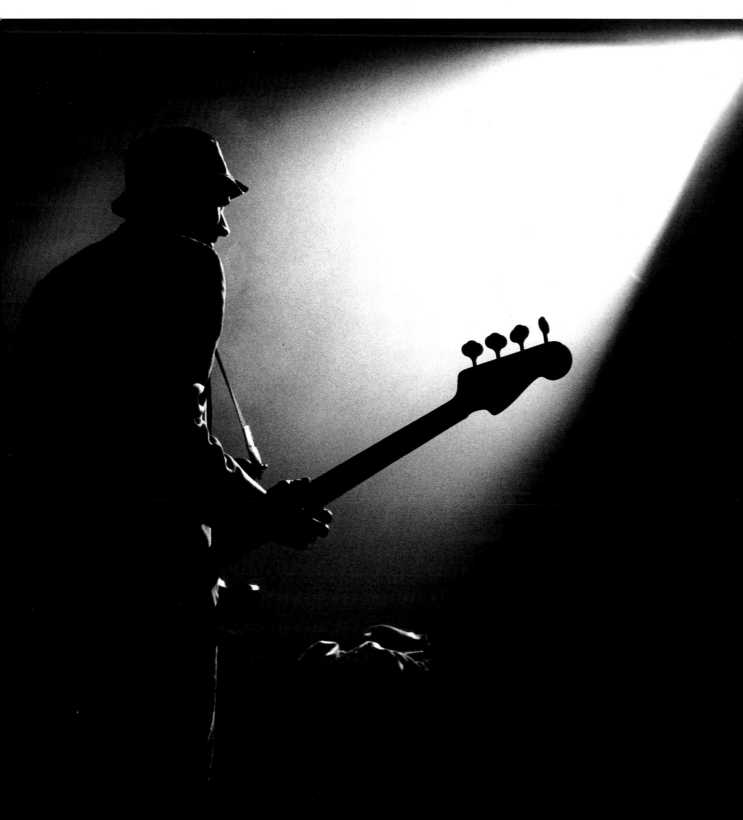

DAMON: That's one of those hats that everyone tried to convince Alex wasn't a good idea but he sort of ignored us.

DAMON AND GRAHAM: We've both hurt ourselves doing that. *GRAHAM:* I almost knocked myself out at Colchester and I always have to land on one knee - I learnt not to land on that one.
DAMON: My main complaint after gigs is having people pull off my T-shirts and trapping the veins in my neck. I've had a couple of fractures - it's quite hazardous really. Good Blur gigs end up with some kind of injury.

GRAHAM: That looks like you're trying to have a crack on a spaceship.

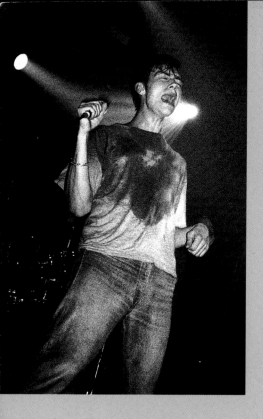

GRAHAM TO DAMON:
You're about as sexy as a stuffed fish, pal.

ALEX: Ooh, I could shag you there.
DAMON: That is sweat, mate.
I have to wear a new T-shirt every night, I throw them into the audience.
One day I'm going to go 'round the world and reclaim all my T-shirts.

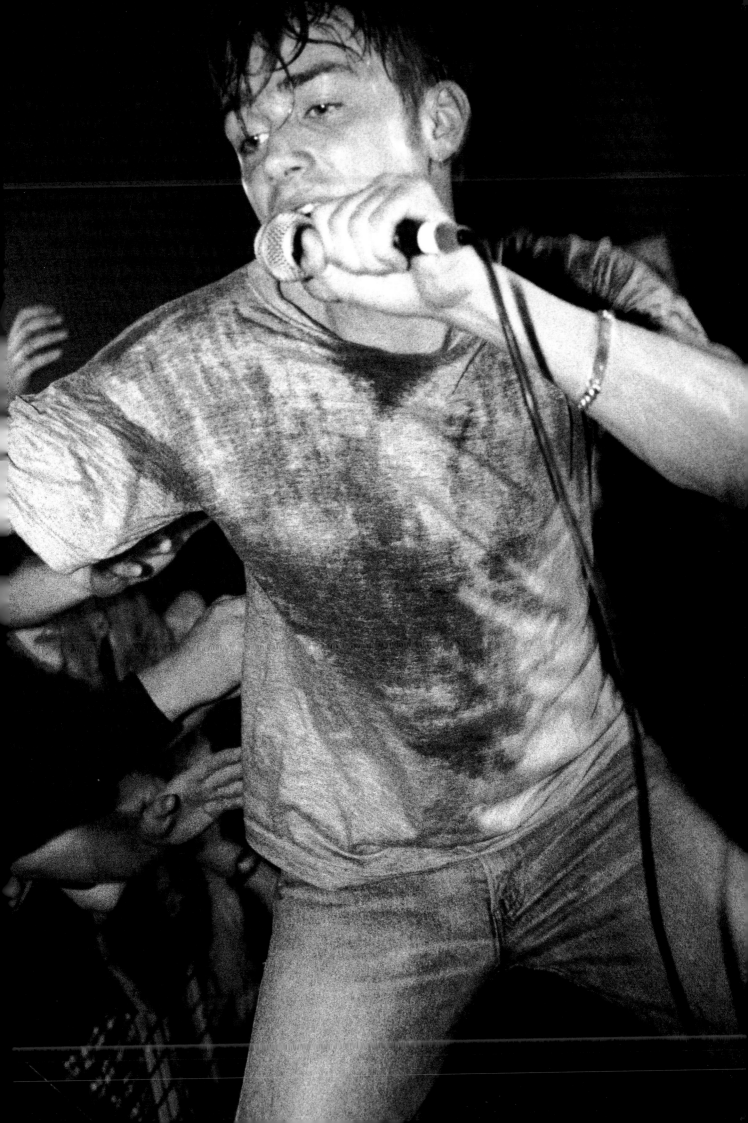

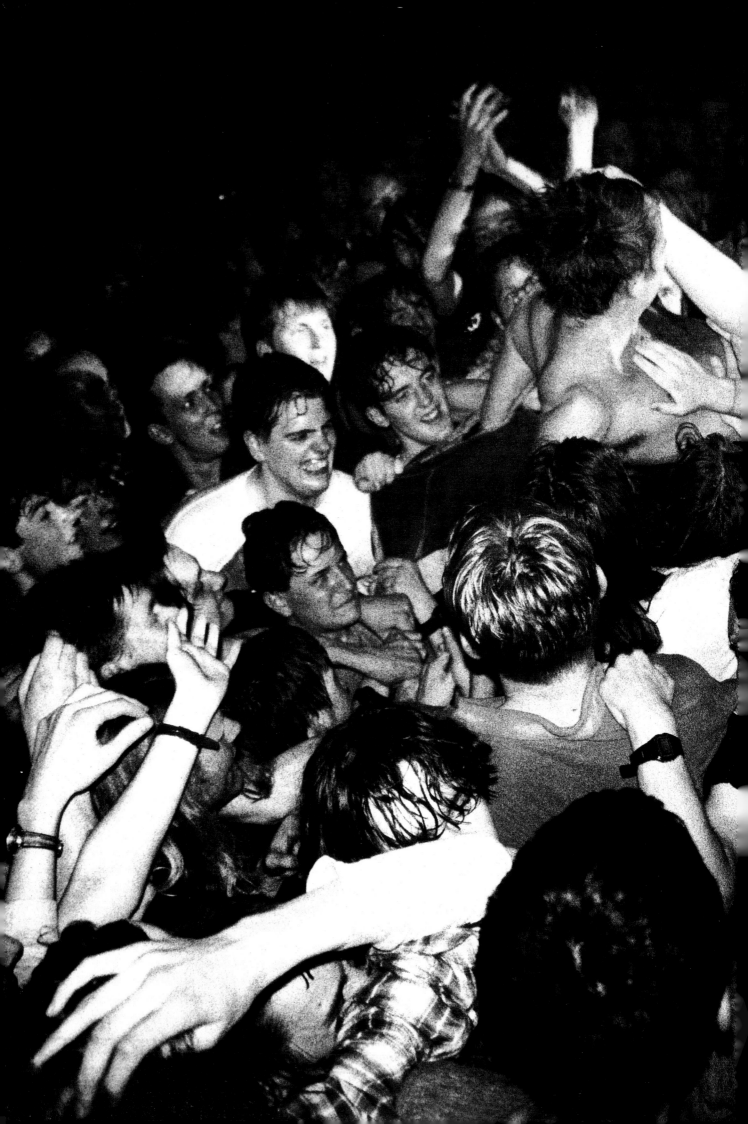

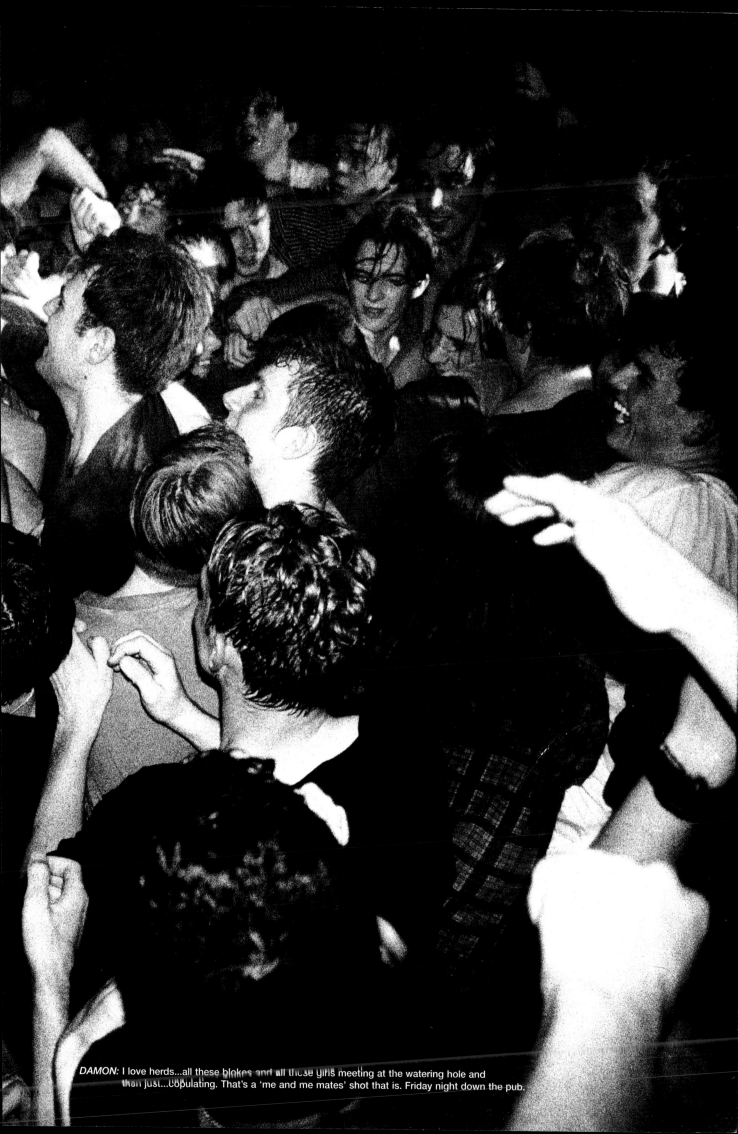

DAMON: I love herds...all these blokes and all these girls meeting at the watering hole and then just...copulating. That's a 'me and me mates' shot that is. Friday night down the pub.

DAMON: We only had three things to say in our first interviews: we're great, we're not an indie band and don't judge us now - judge us in five years' time. At least now we've done something that lives up to my big mouth.

DAMON: My mum thinks I'm ultra-conservative in the way I dress.
Hippy parents just don't understand why you want to wear a shirt and smart shoes.
Ha!

DAMON: People should smarten up, be a bit more energetic.

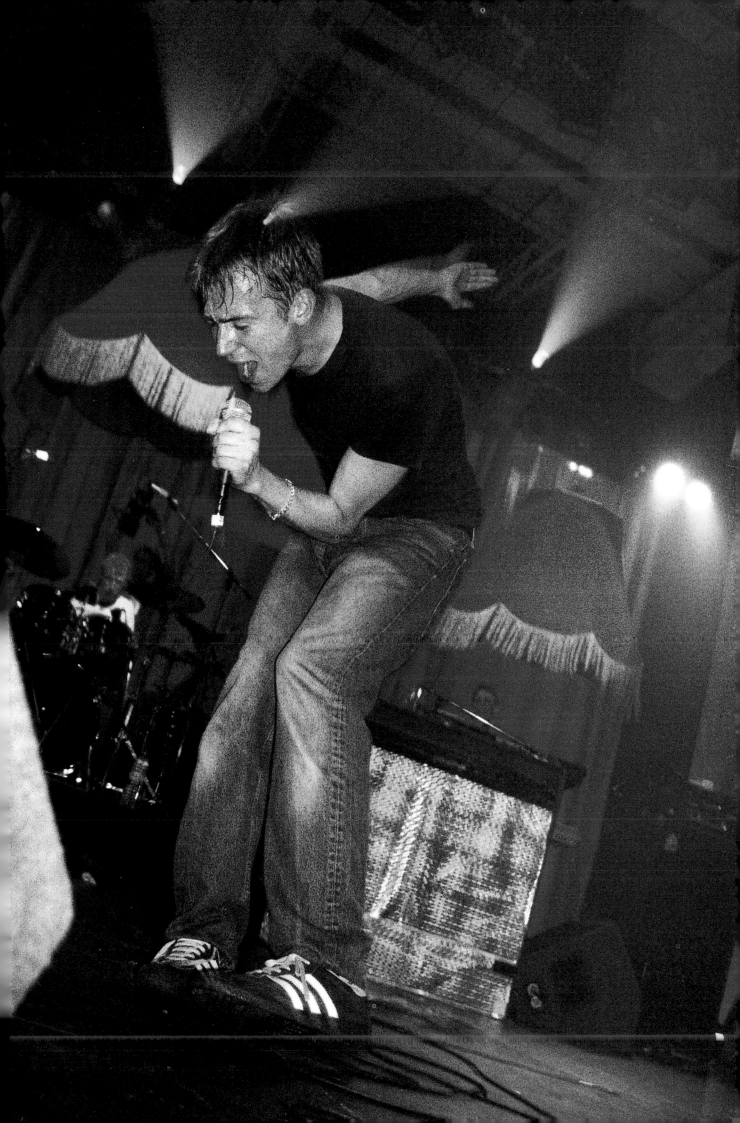

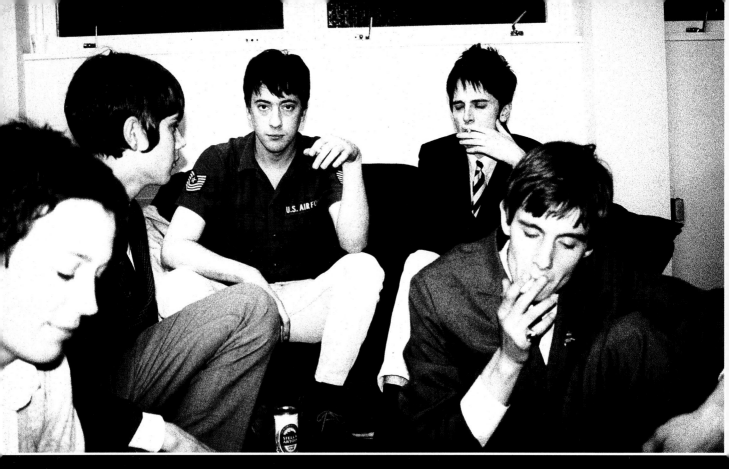

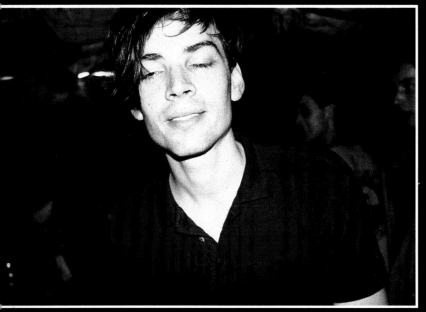

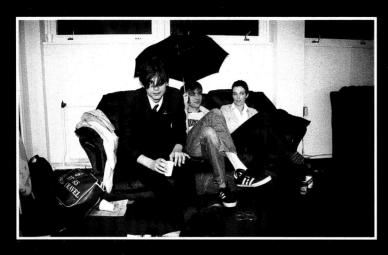

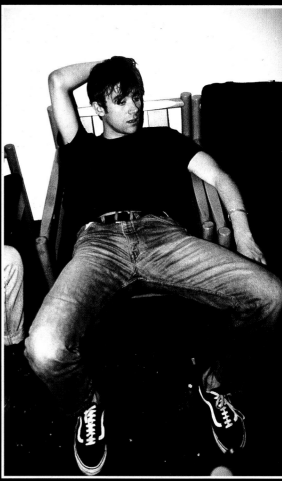

DAMON: One night we went to a private view where all the drinks were free and the only thing I can remember is waking up at 5 o'clock in the morning in a cell at Holborn Police Station sitting next to a Gurkha.

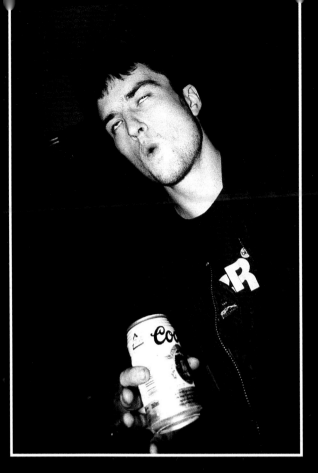

DAMON:
I used to go to loads of parties and whenever I got there, Graham would be lying on the ground like a human doormat.

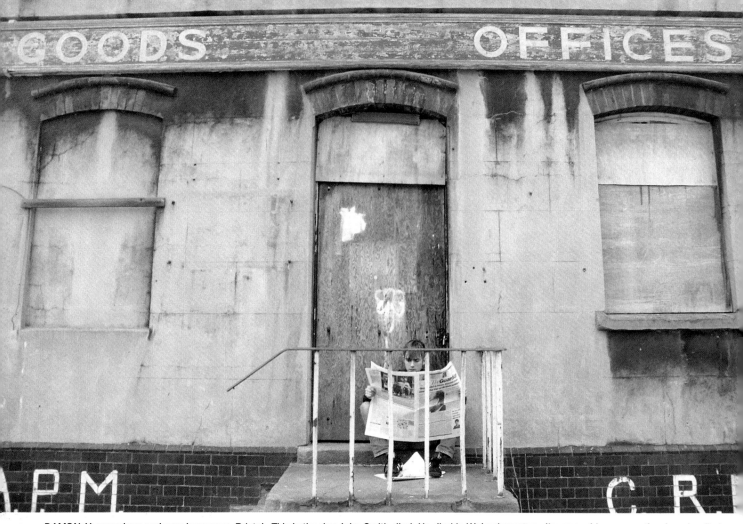

DAMON: Very anxious and very hungover...Bristol...This is the day John Smith died. He died in Wolverhampton...I'm sorry, I know exactly where he died. He died at his home and they didn't get it in the papers 'til the day after. This was the day after.

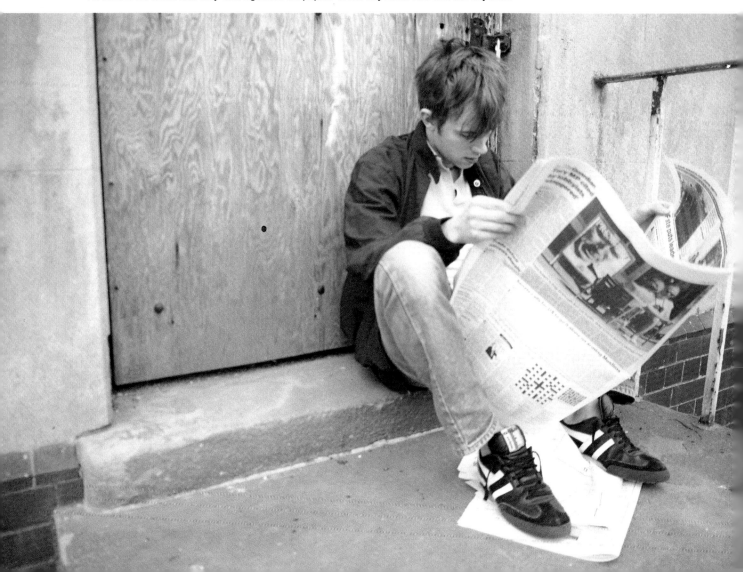

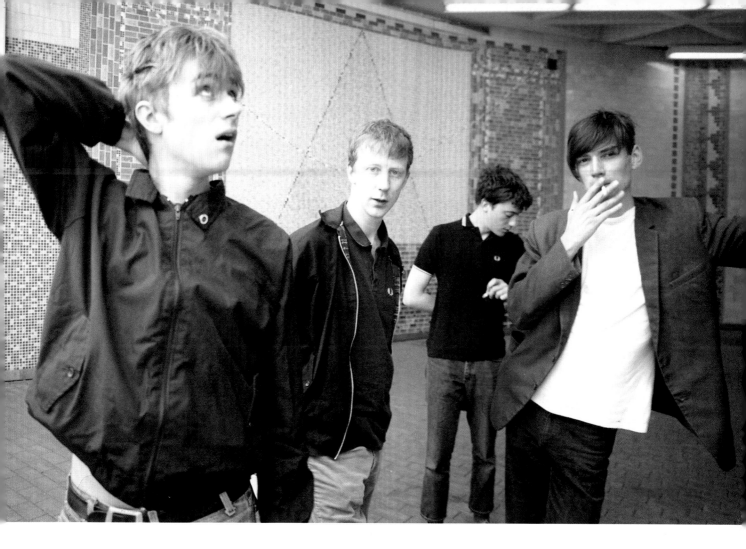

DAMON: I'm wearing Graham's shoes because in Wolverhampton I jumped into the audience and lost mine. They called me Jesus when I came out.
DAVE: It's nice to see me standing at the front. GRAHAM: You're not standing at the front, you're standing nicely towards the back as usual.
DAMON: One of our roadies is a massive Wolverhampton fan and he told us about that particular underpass where the tubeway army used to hang out
and beat up Birmingham City and Aston Villa fans.

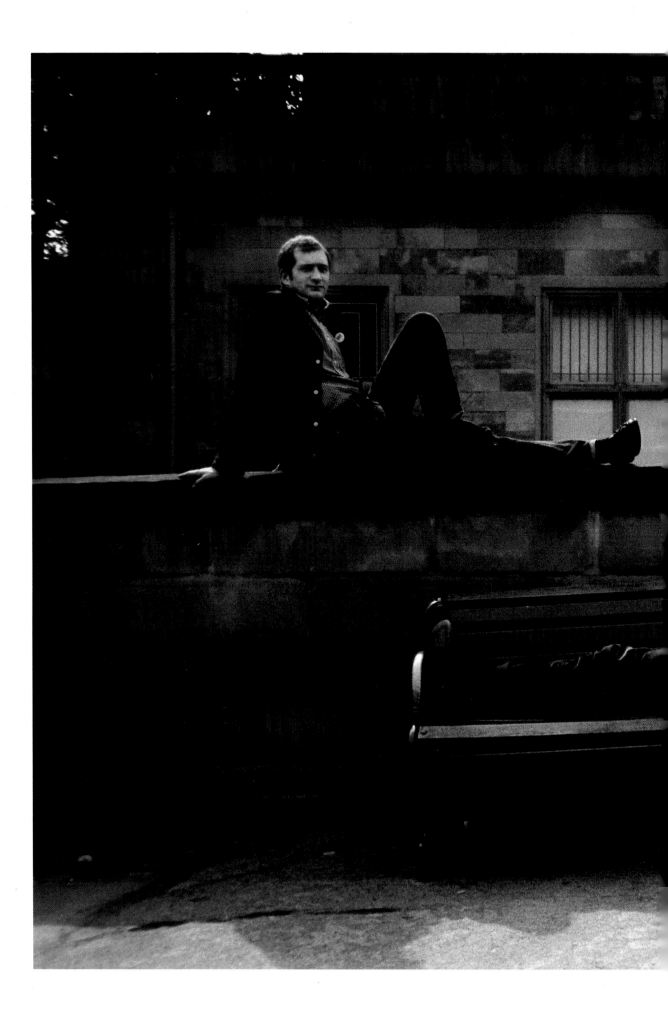

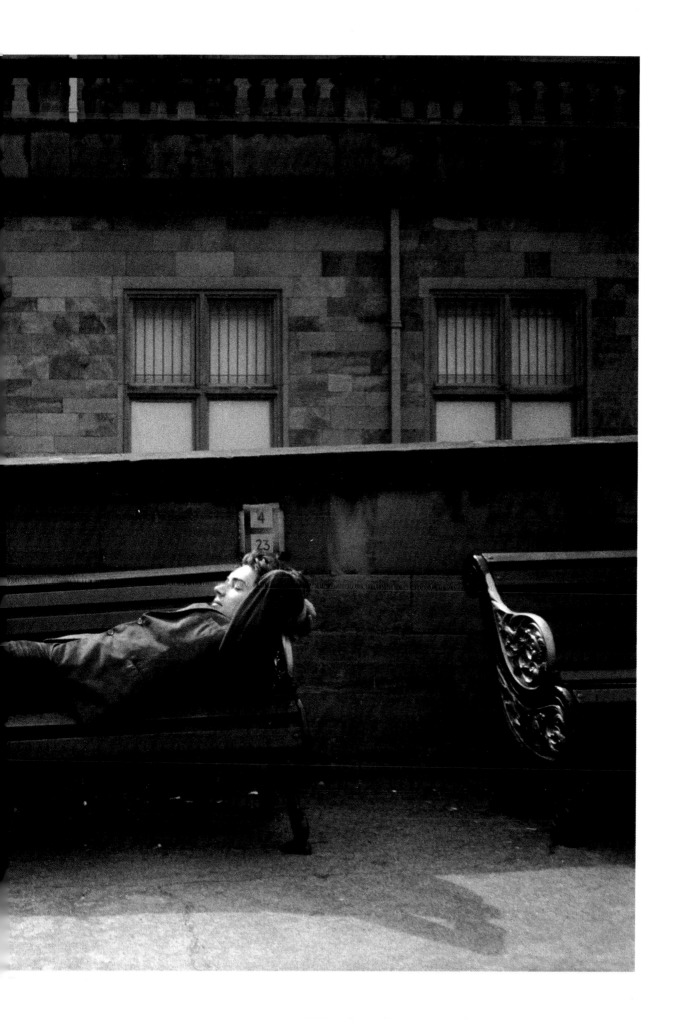

ALEX: England's all right, you know? We discovered light-emitting plastics.

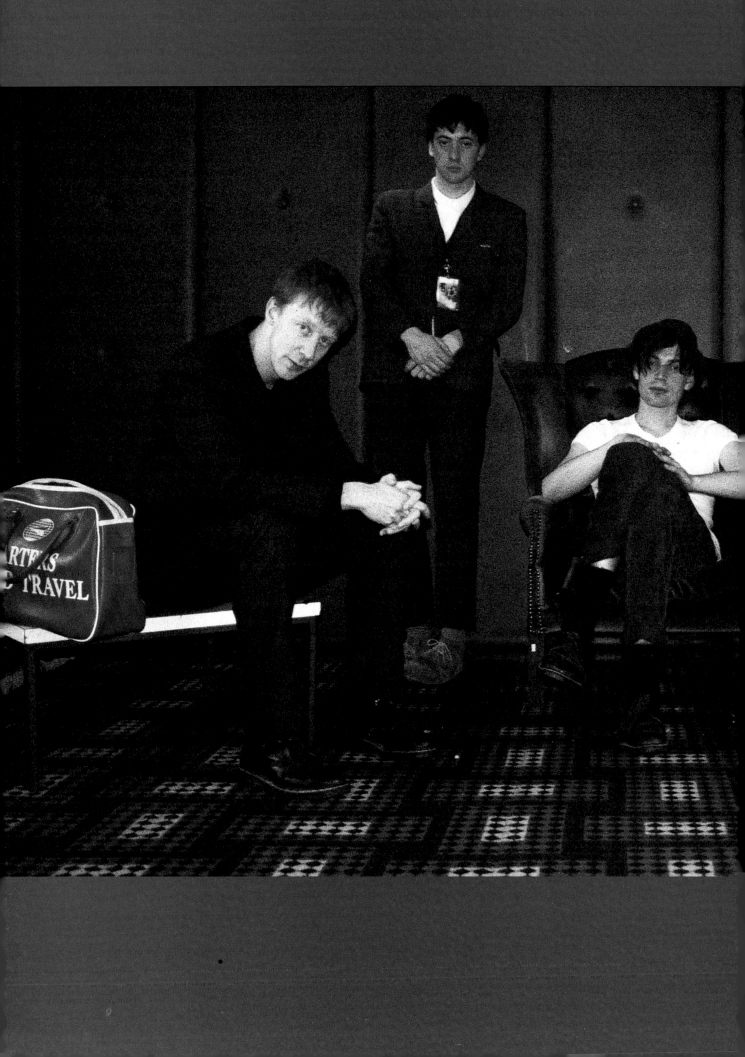

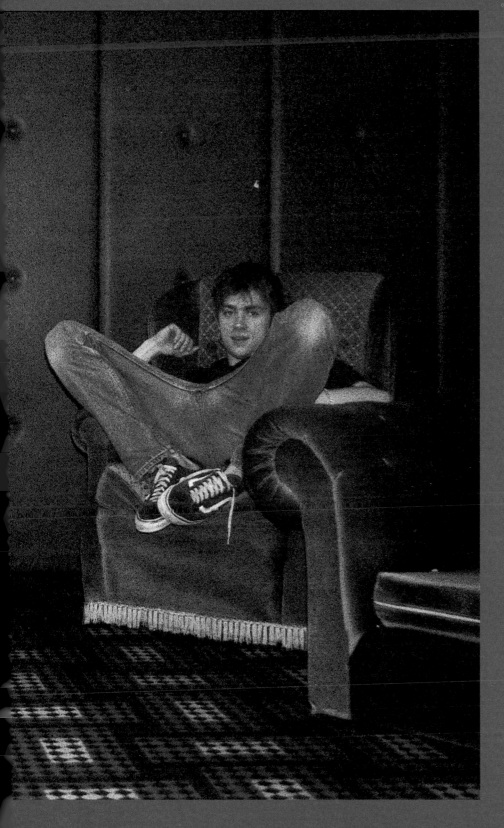

ALEX: That's Wolverhampton City Hall...one of the best dressing rooms in the country.
Bands aren't just about music, they're about everything you care about when you're
sixteen - good haircuts, your mates, sex, smoking, drinking and just looking good.

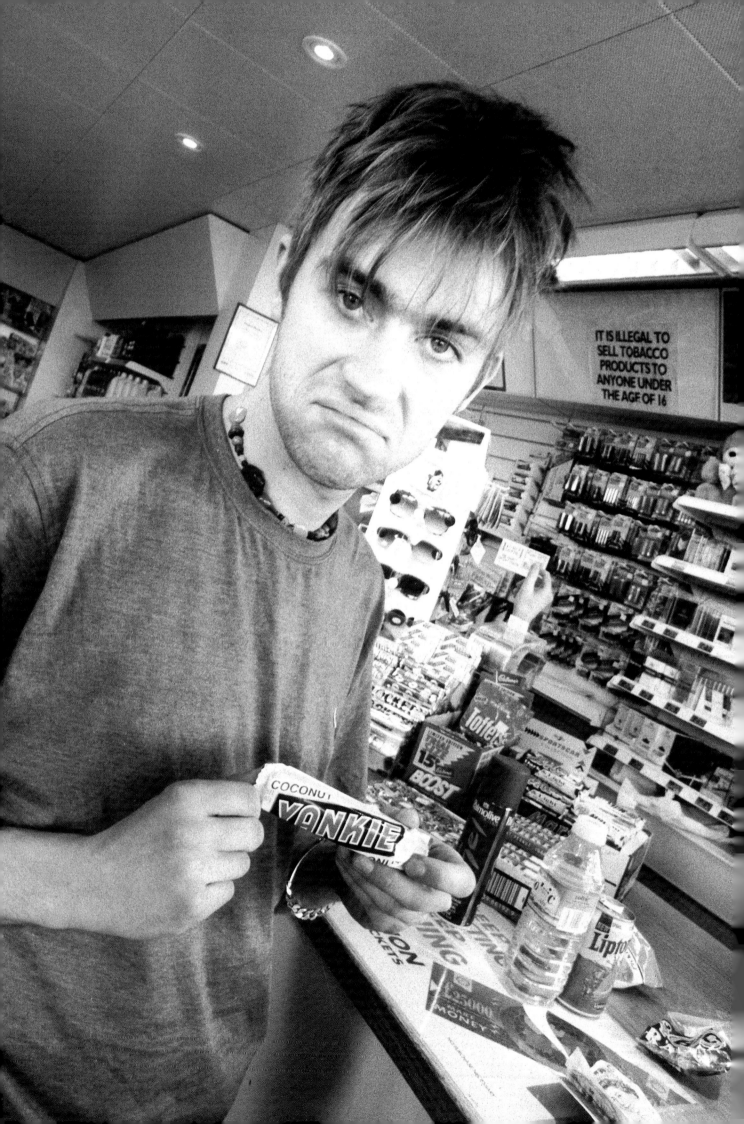

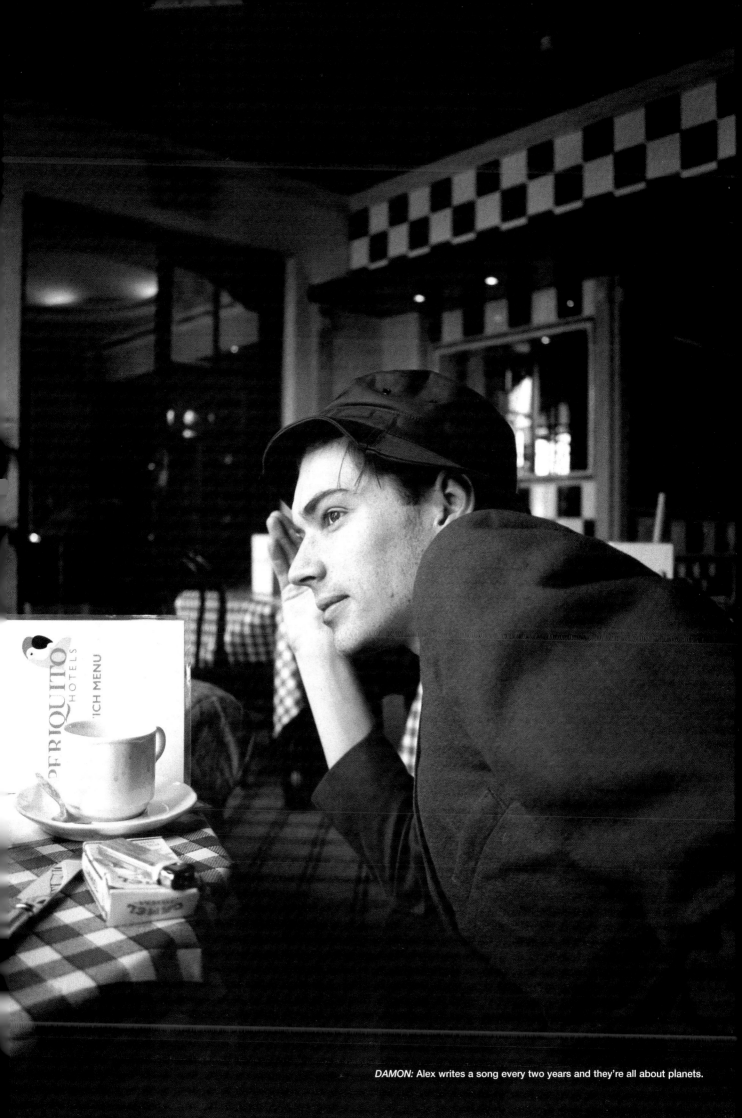

DAMON: Alex writes a song every two years and they're all about planets.

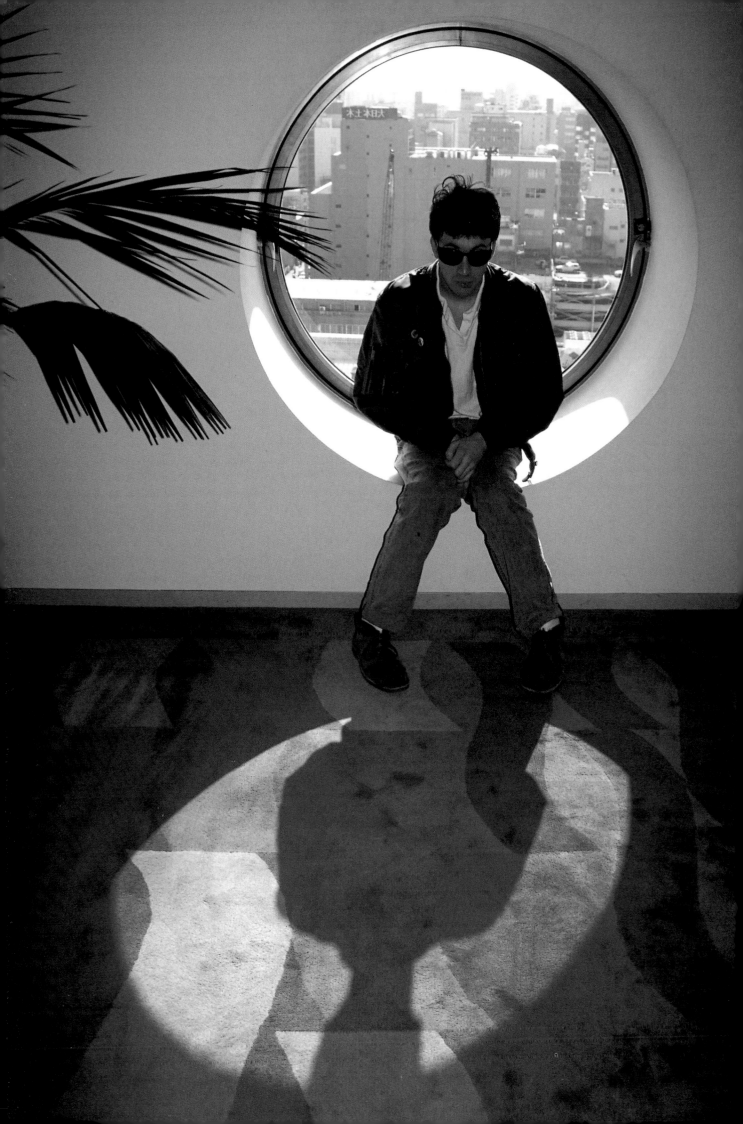

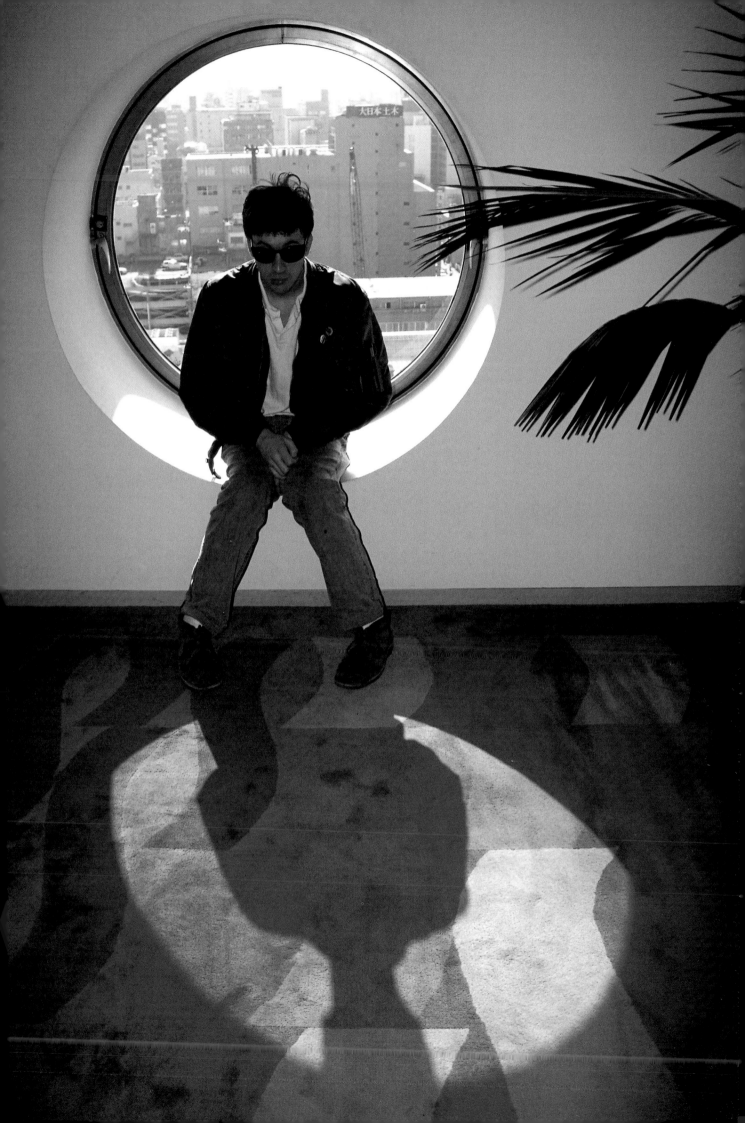

IPSWICH

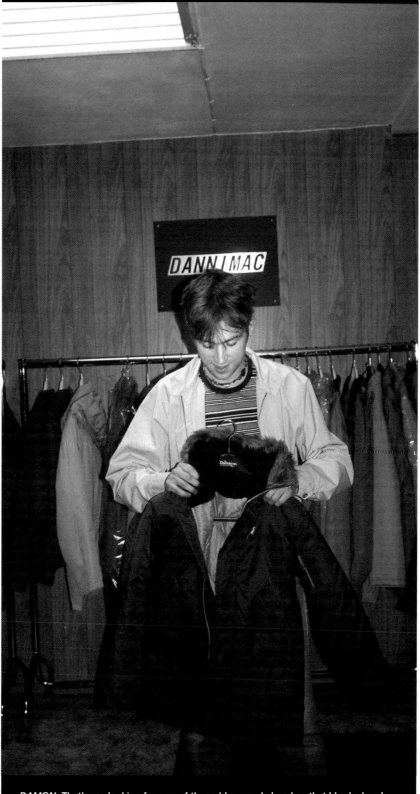

DAMON: That's me looking for one of those blue snorkel parkas that I had when I was twelve...I found one, a new one, but it was about a twelve-year-old's size, so I couldn't have it.

HAZEL CLOVER Ipswich Evening Star *3rd March 1994:*
We look forward to the return of Blur and hope it is as successful as the Levellers gig

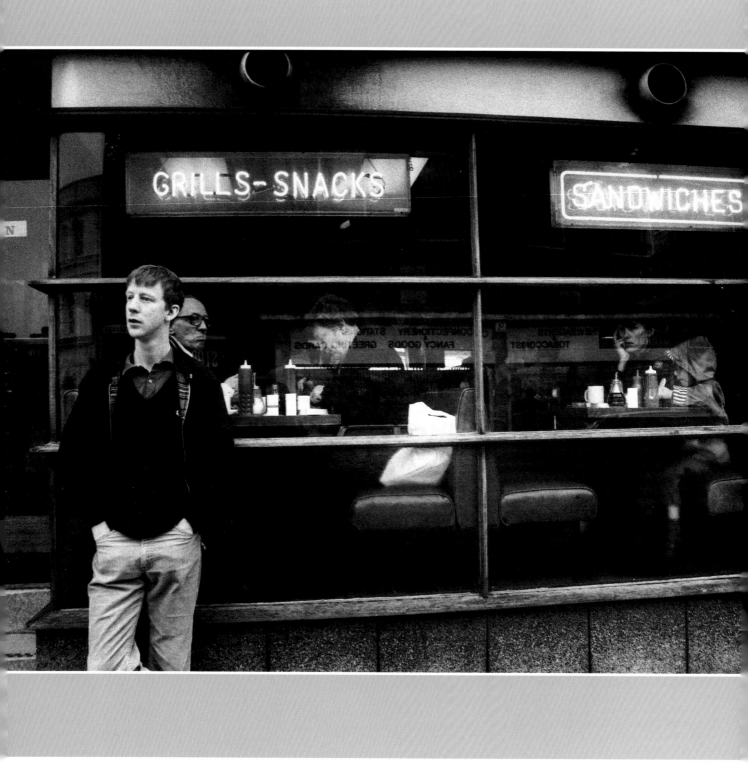

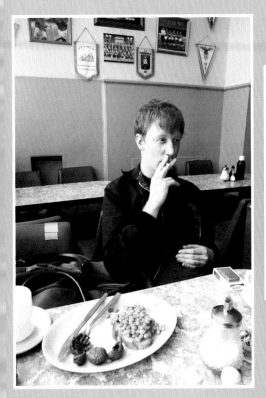

The Express Cafe, Wolverhampton.
DAVE: I had mushrooms, beans and some toast.
ALEX: I had an omelette and chips. Cheese omelette.
 I always have cheese omelette and chips.
DAMON: I think Dave still had slightly dyed hair there,
 looking very young there, Dave.

CARA

DAVE: We don't eat anything with eyes, except potatoes.

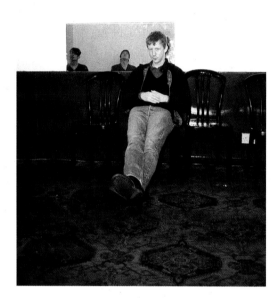

DAVE ON THE INTERNET:
I wouldn't say I surf it...I'm more of a pedestrian.

DAMON: There's a degree of disgust in the way I look at those holidays in *Girls & Boys.* But, yes, I am also quite lustful towards them. I like the sexual vulgarity of it all. I'm 26 now and this is me just sort of preparing for my 'dirty-30s'.

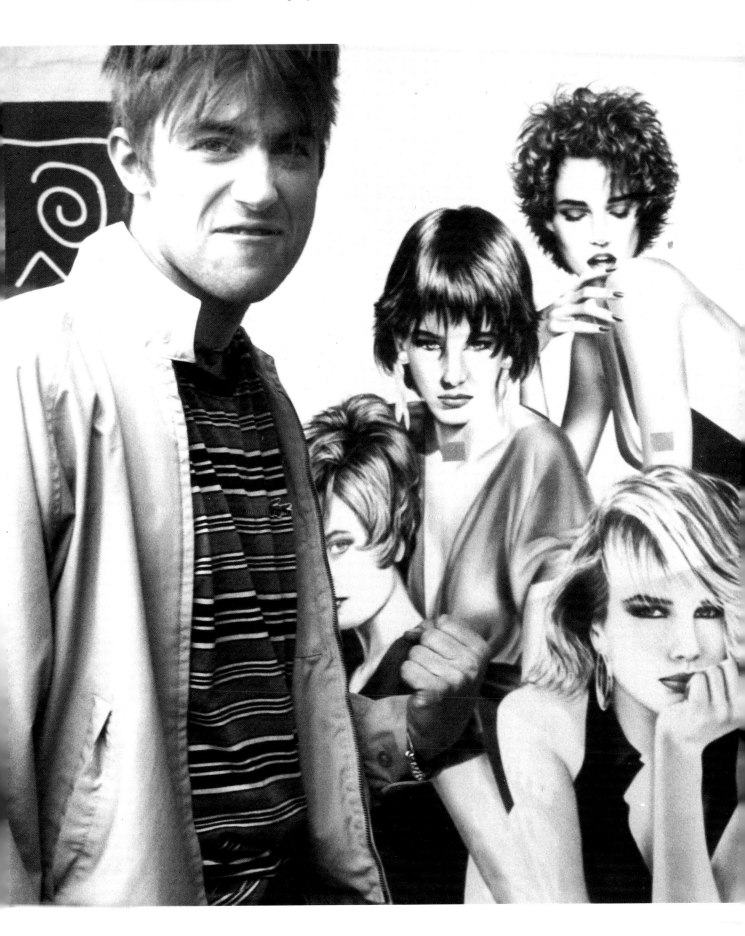

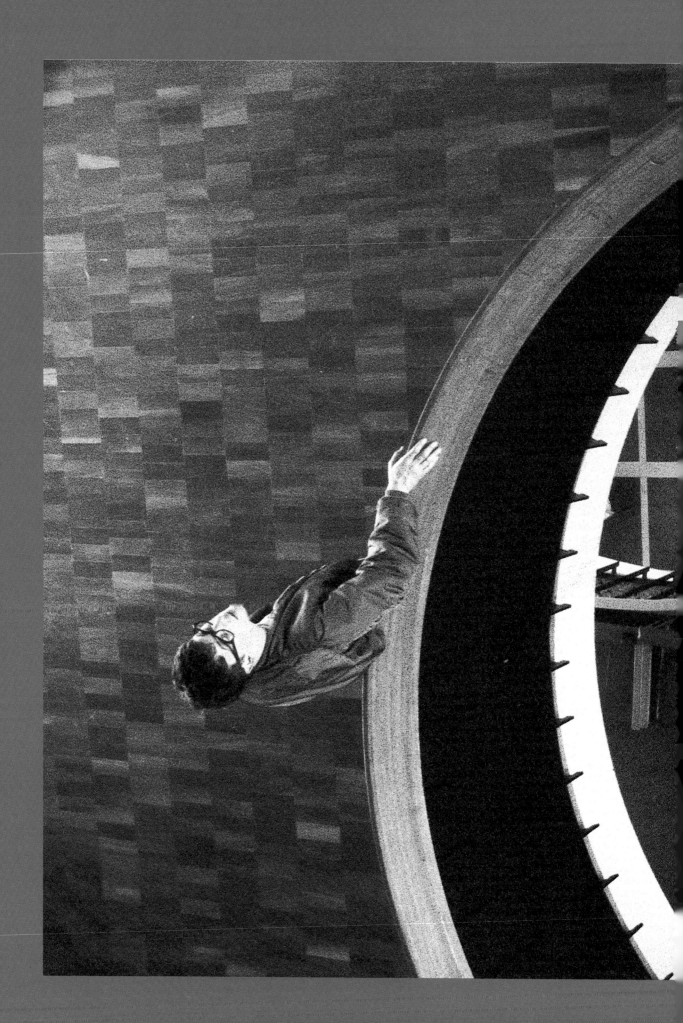

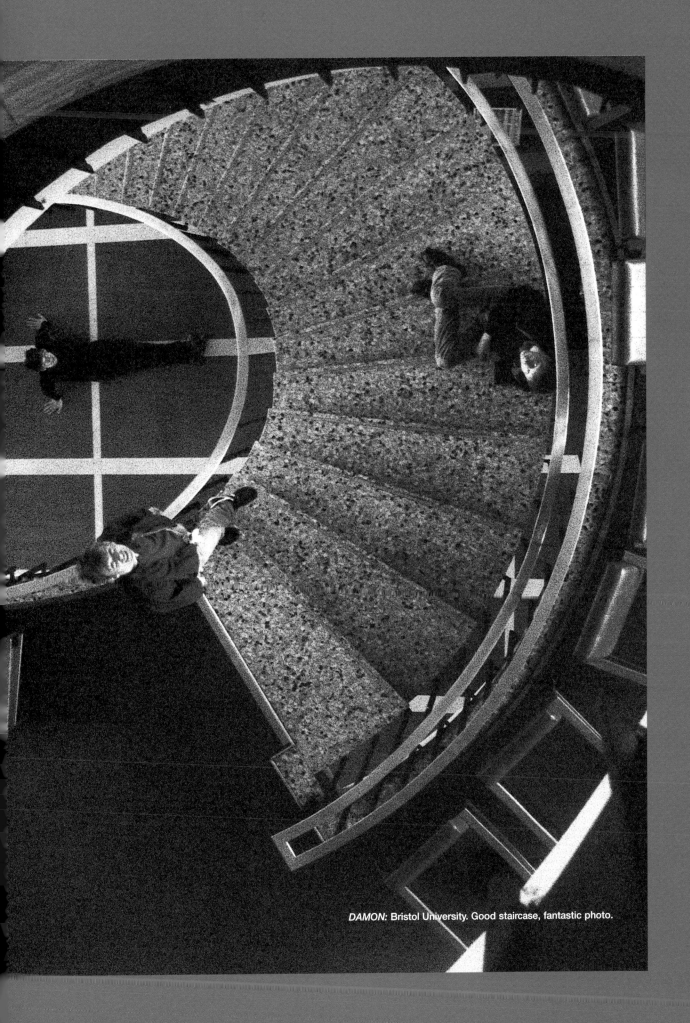

DAMON: Bristol University. Good staircase, fantastic photo.

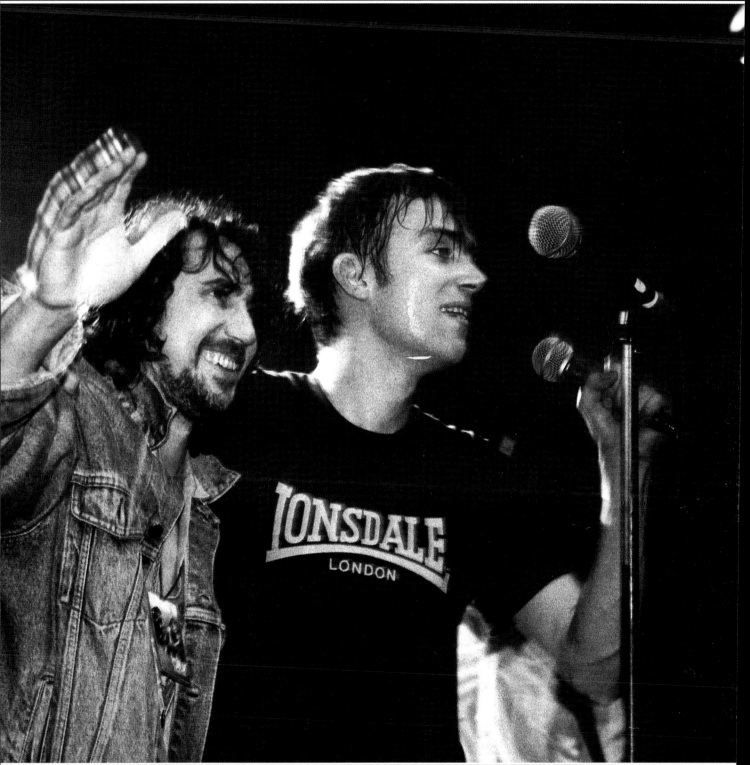

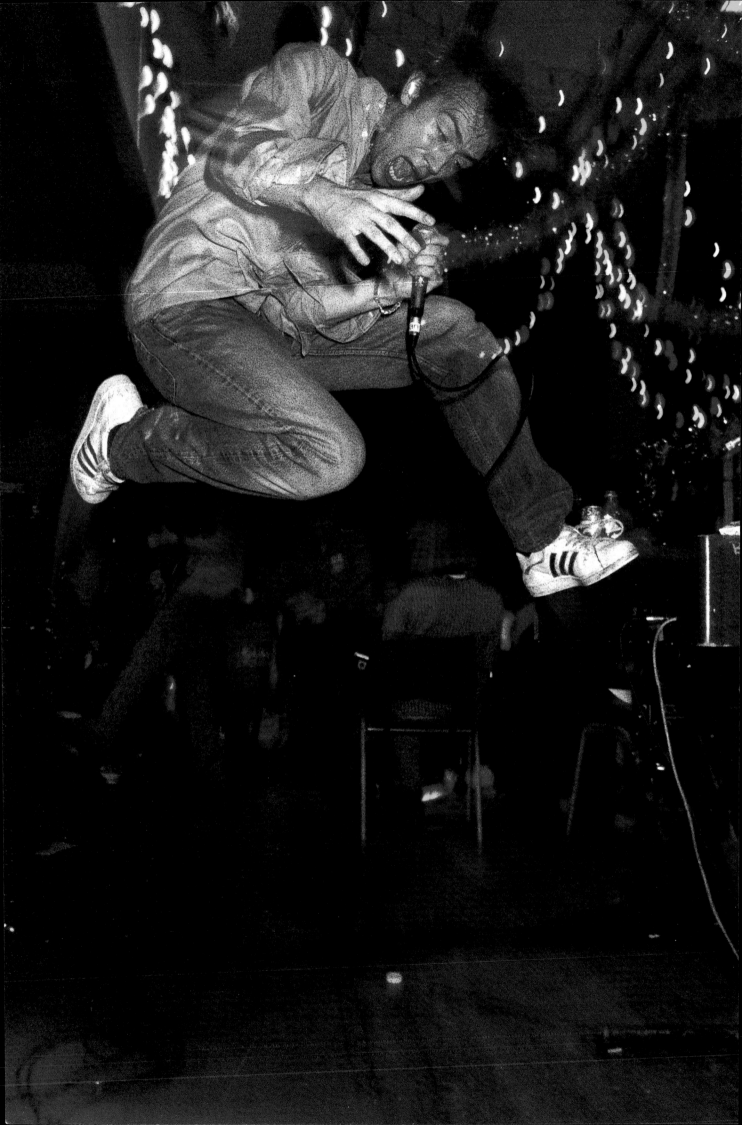

COLCHESTER

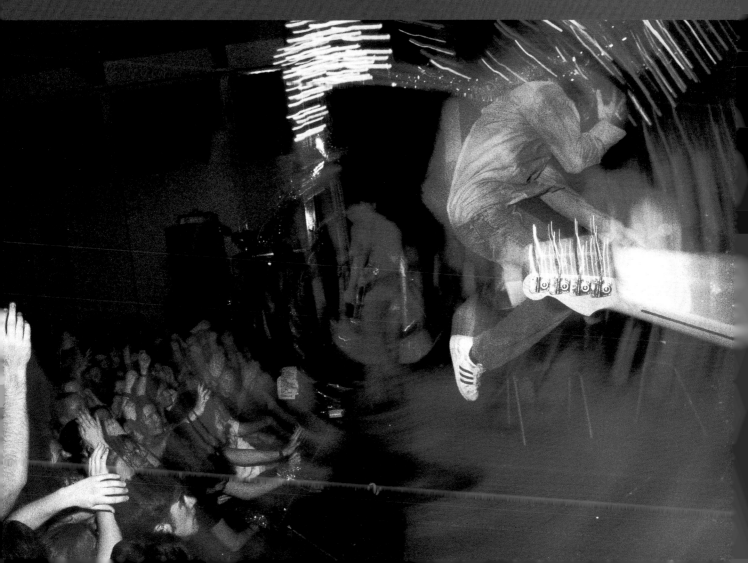

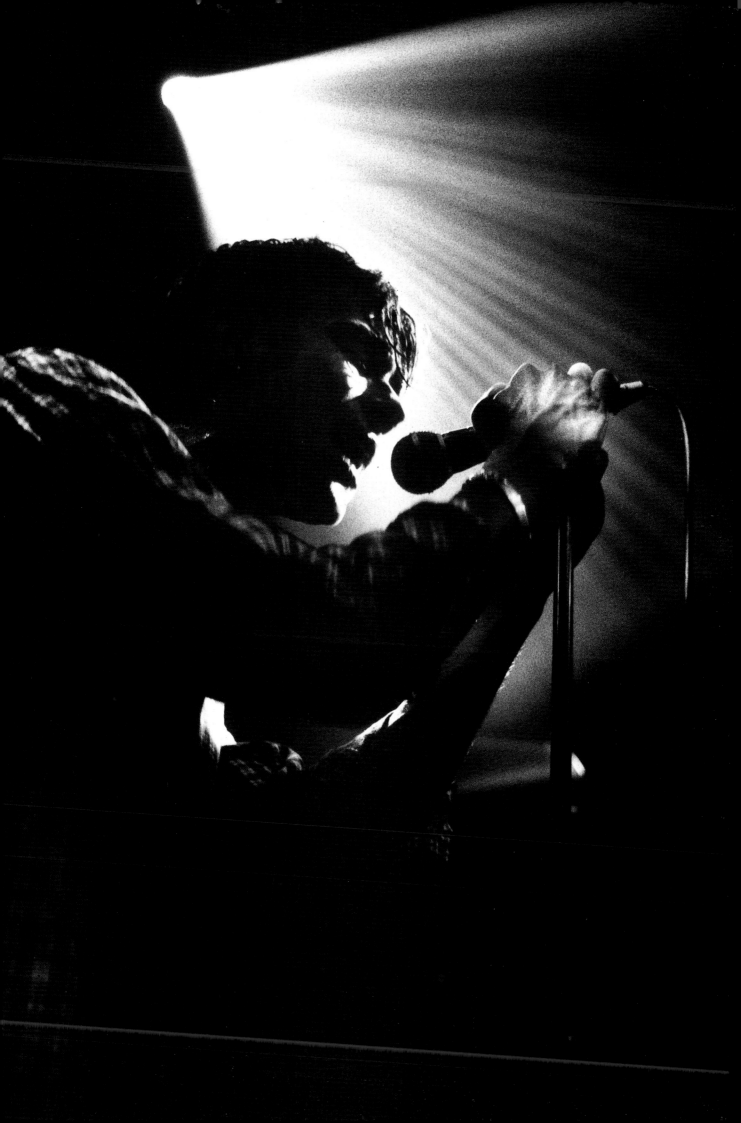

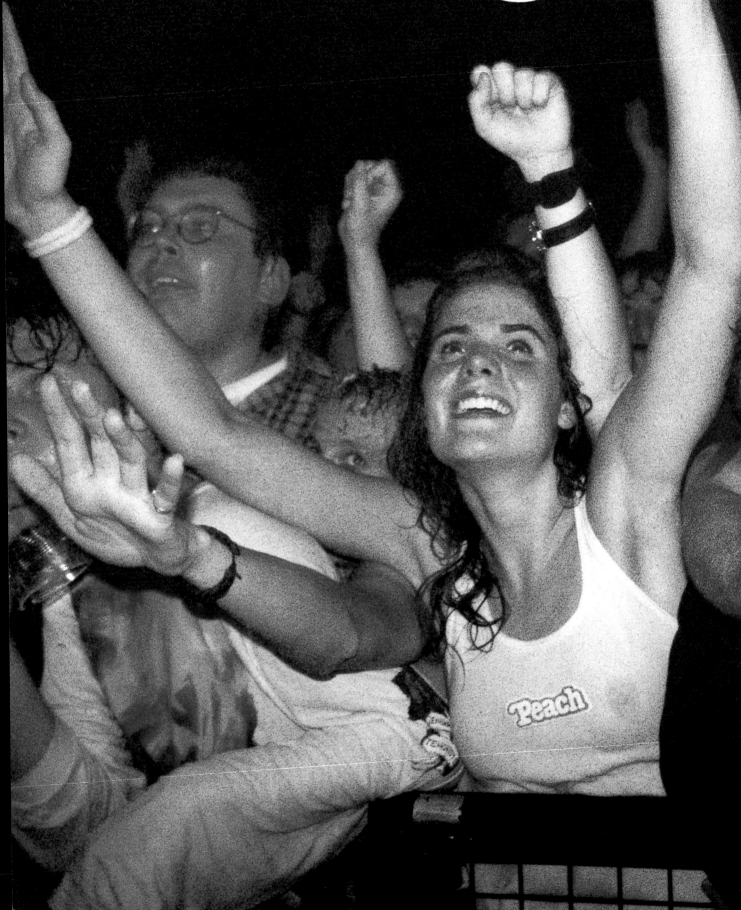

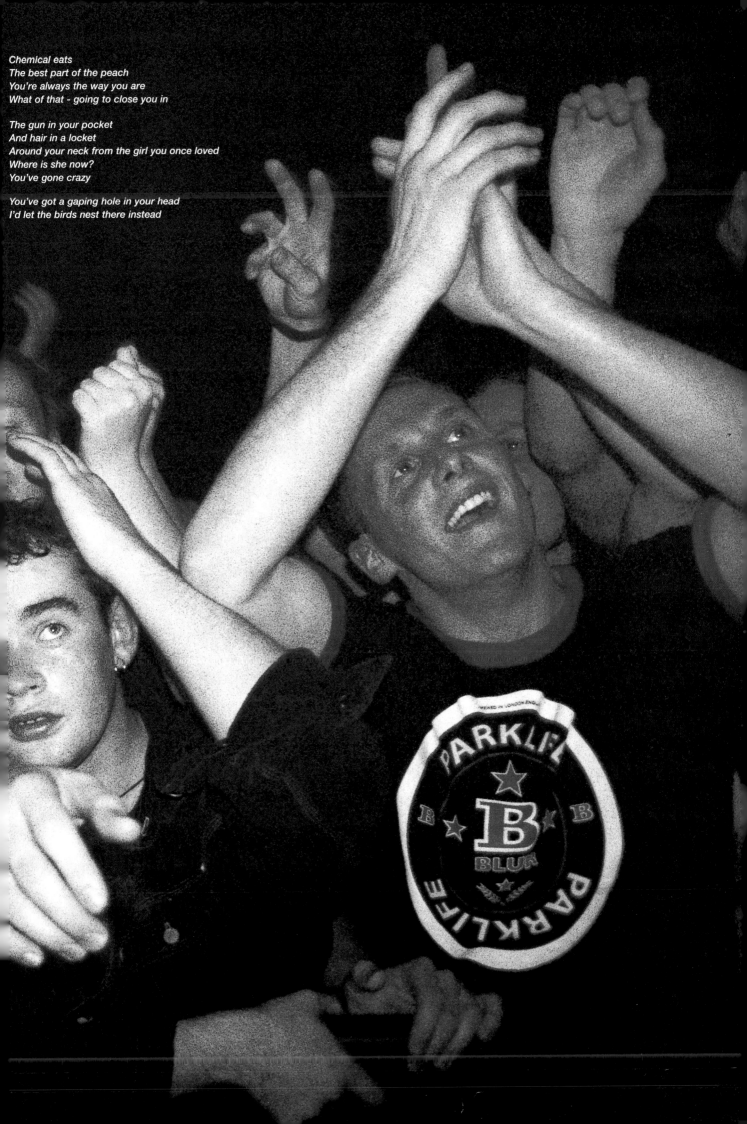

Chemical eats
The best part of the peach
You're always the way you are
What of that - going to close you in

The gun in your pocket
And hair in a locket
Around your neck from the girl you once loved
Where is she now?
You've gone crazy

You've got a gaping hole in your head
I'd let the birds nest there instead

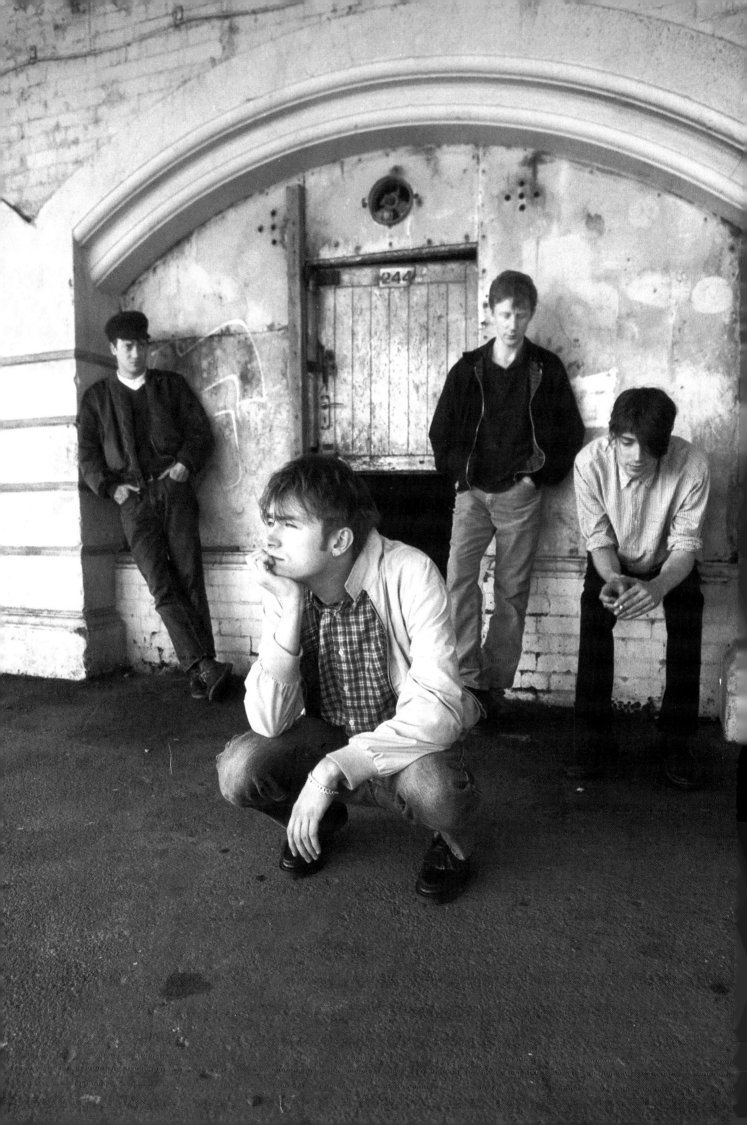

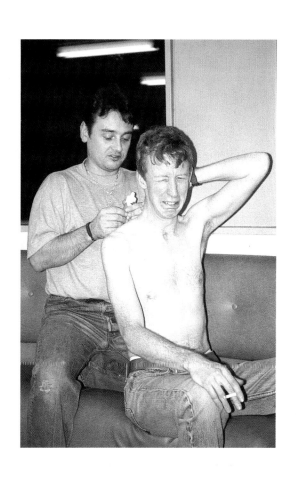

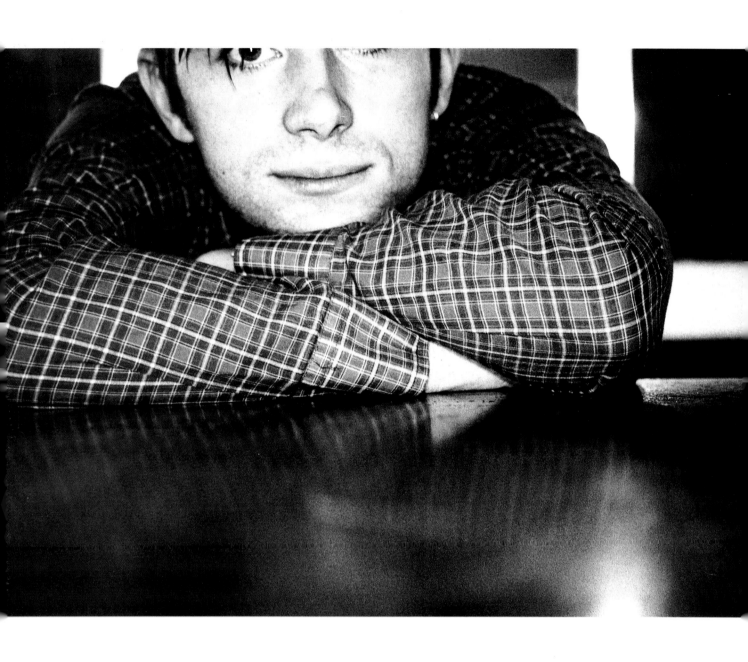

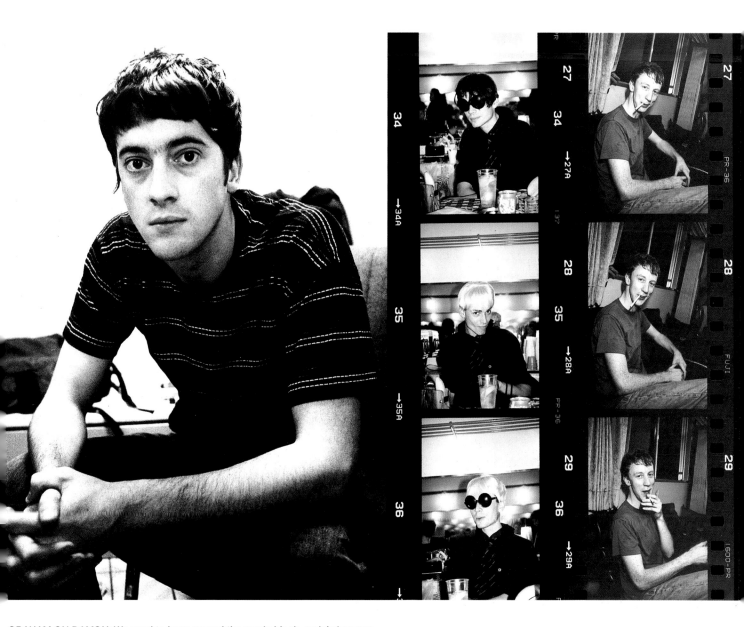

GRAHAM ON DAMON: We used to hang around the music block, mainly because that was where the lads never went. They'd be off in the field playing football and beating people up. I suppose we were the school freaks.

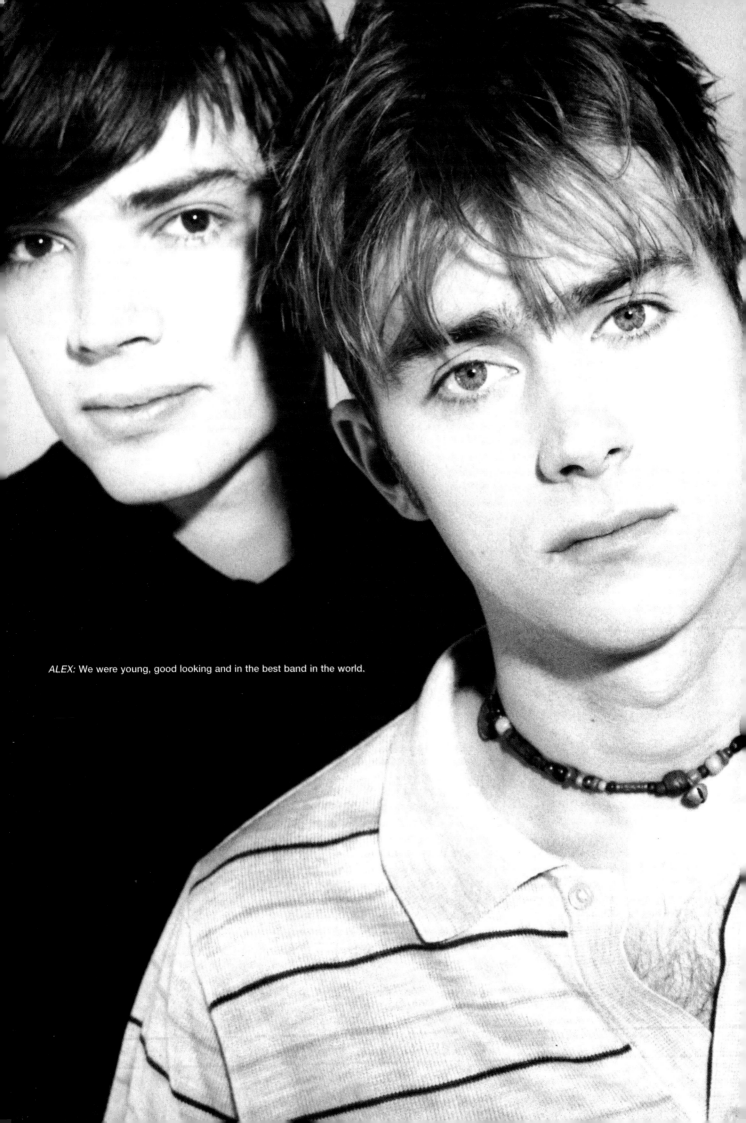

ALEX: We were young, good looking and in the best band in the world.

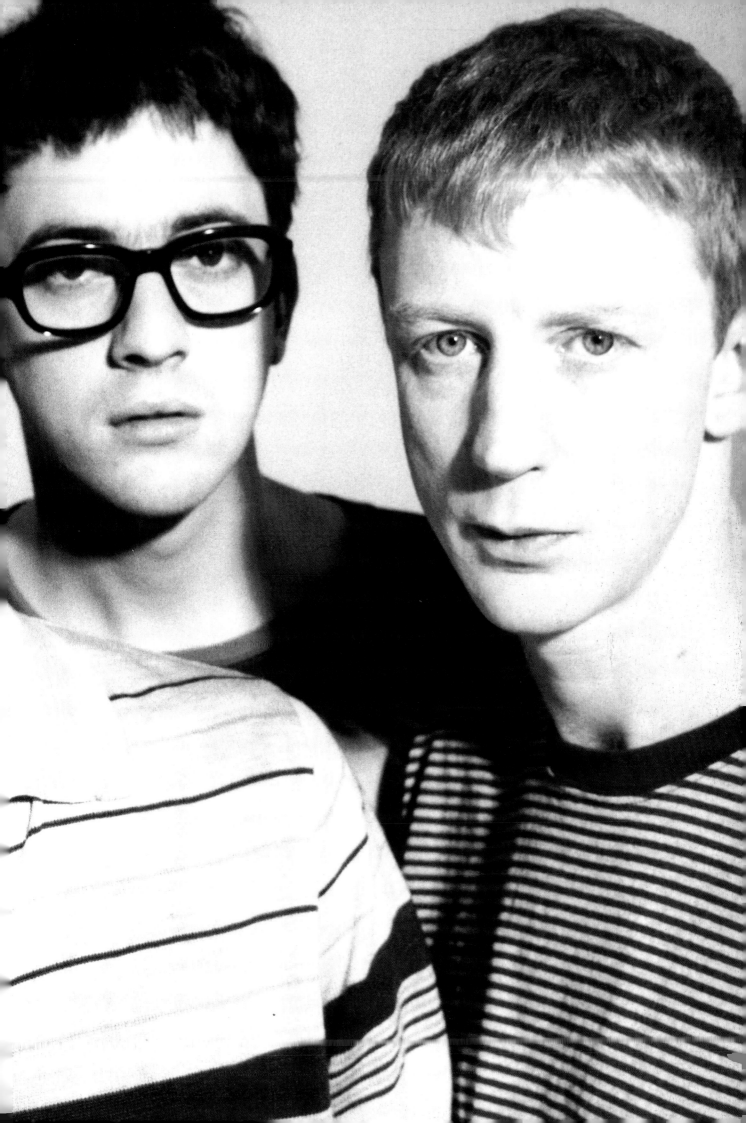

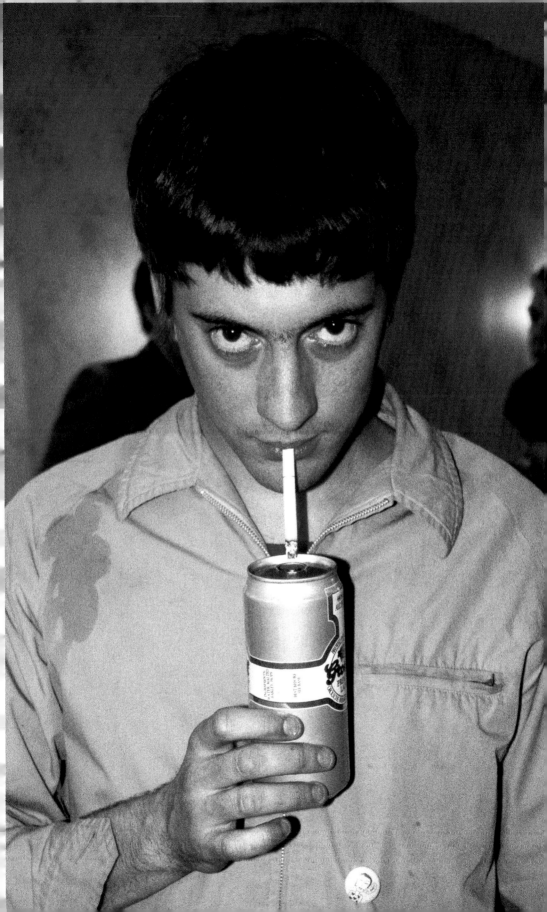

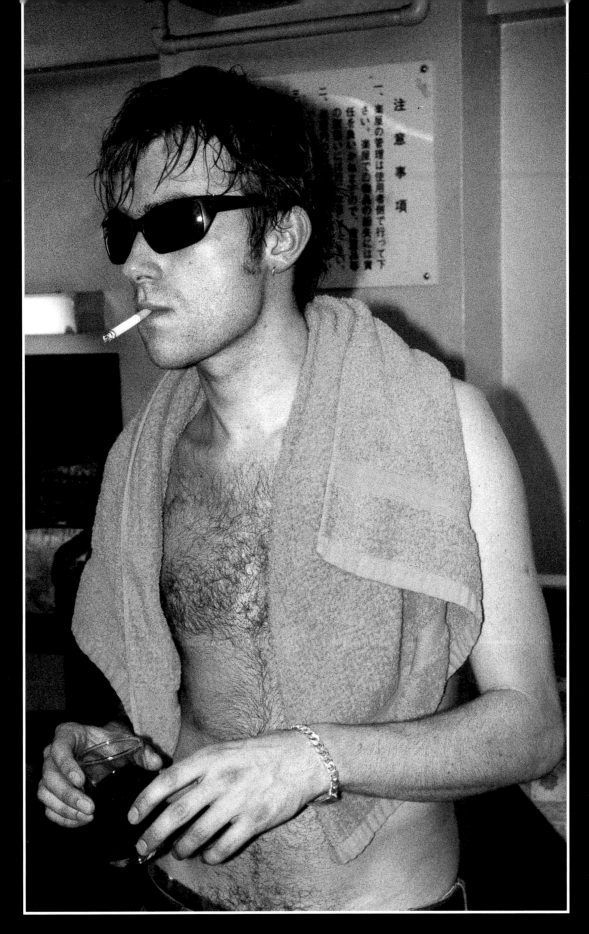

DAMON: Thank God kids these days have got someone to look up to.

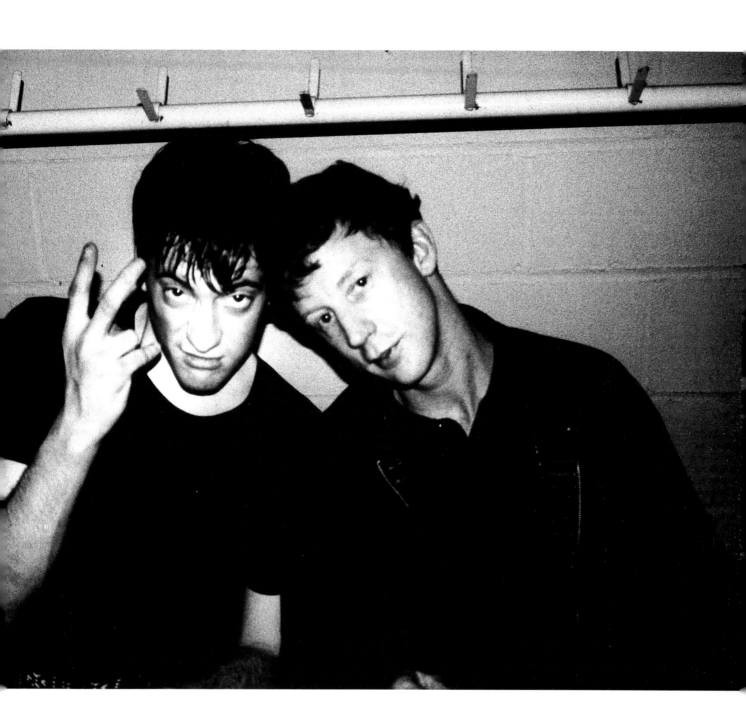

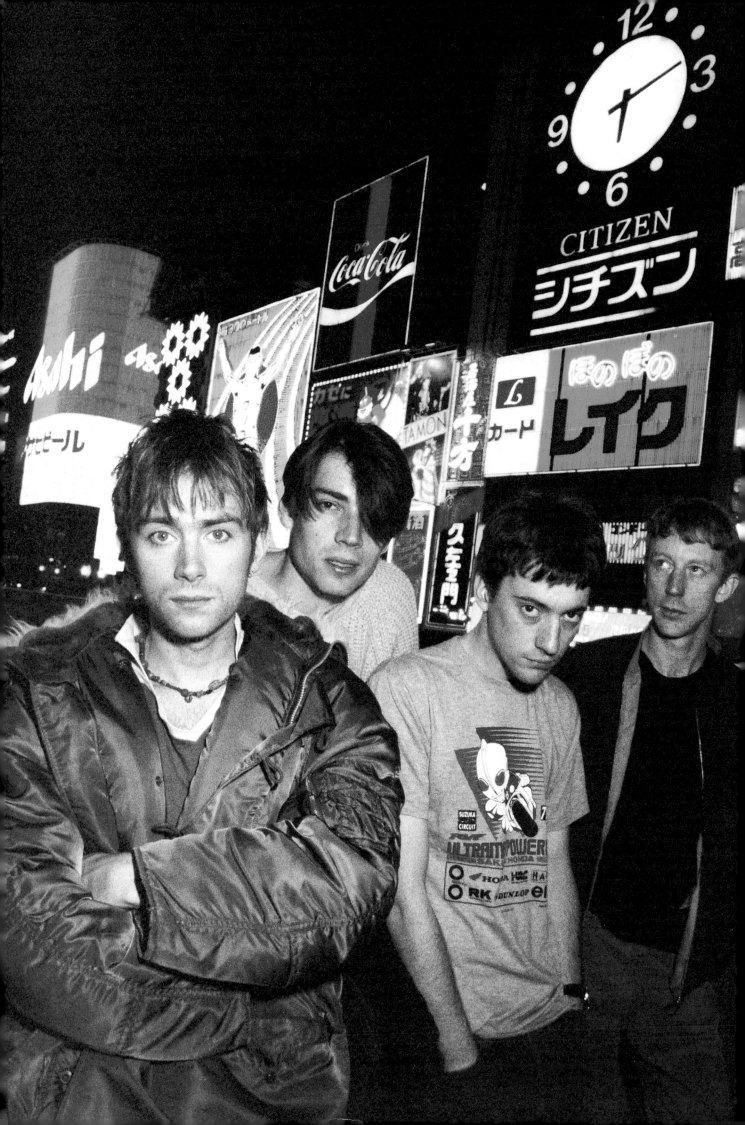

Welcome back elcome back
to to
TOSHIBA EMI TOSHIBA EMI
DAMON, GRAHAM. ALEX &N, GRAHAM. ALEX & DAVE

BLUR BLUR
Welcome back
to
TOSHIBA EMI
DAMON, GRAHAM. ALEX & DAVE

BLUR

GONE
TO MORROW

DAMON: No one likes each other there...no one...I especially didn't like Graham on that day.
GRAHAM: And I hated Alex.
DAMON: You can tell we don't like each other there.

Welcome back elcome back
to to
TOSHIBA EMI TOSHIBA EMI
DAMON, GRAHAM. ALEX &N, GRAHAM. ALEX & DAVE

BLUR BLUR

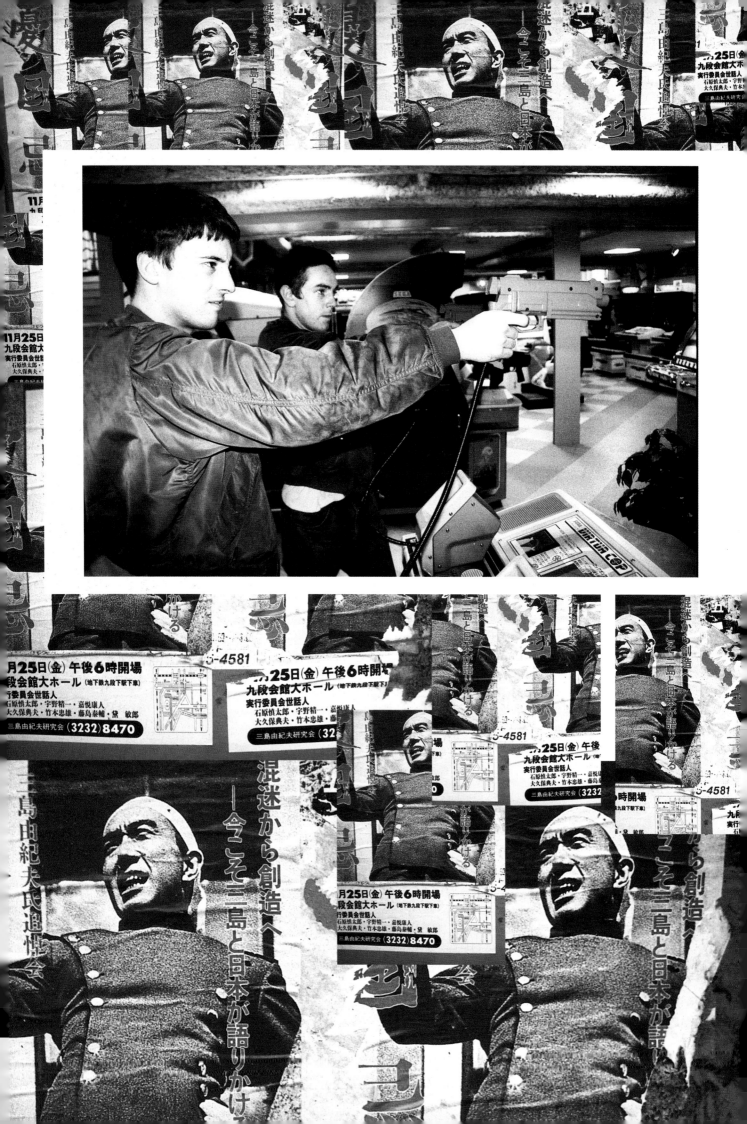

GRAHAM: Of course I'm a hedonist, what else is there to live for? The rest is just killing time.

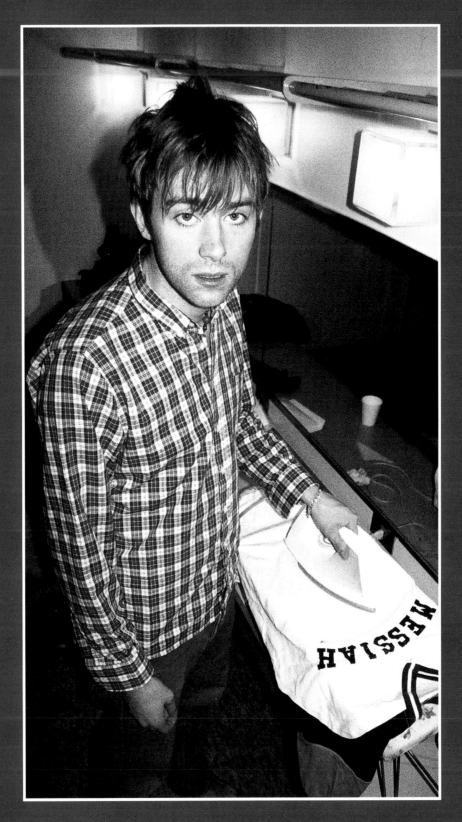

DAMON: The Messiah irons his own shirt.

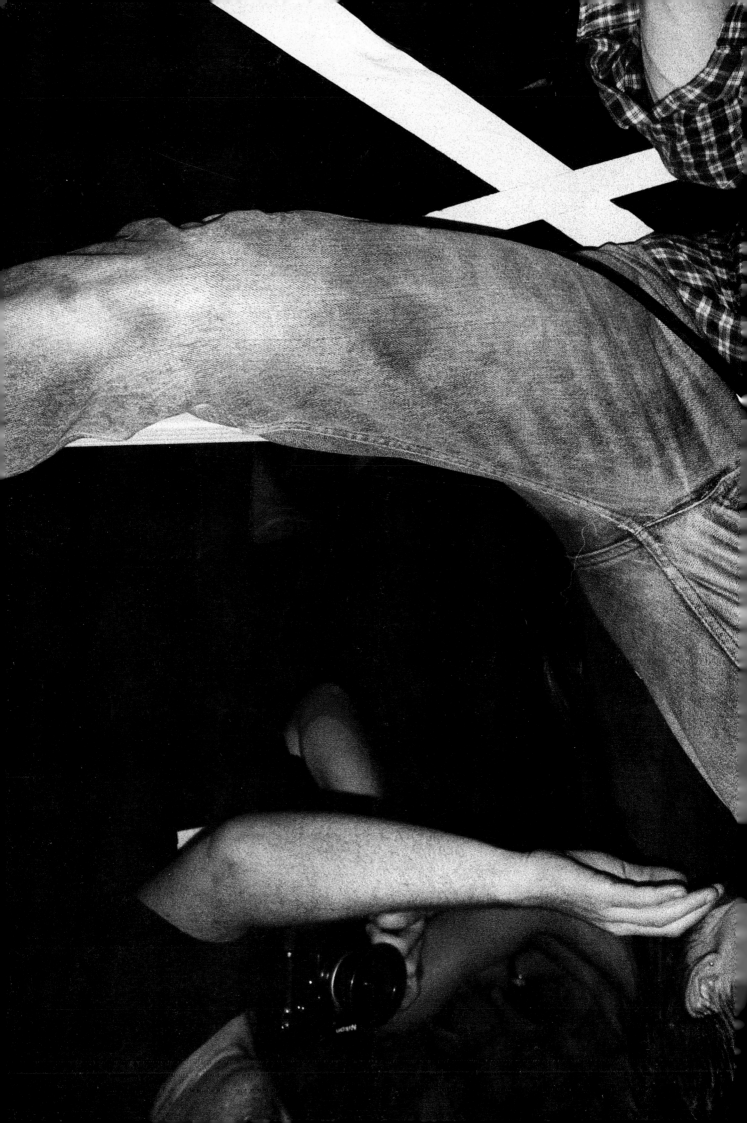

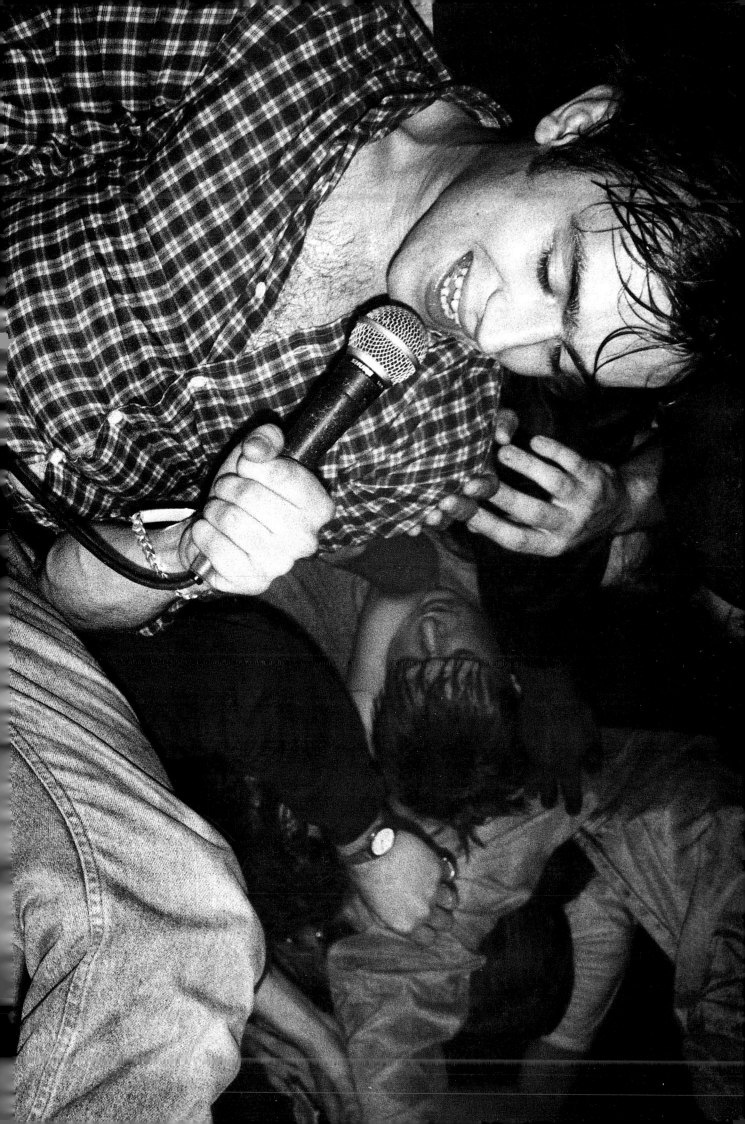

DAMON: I'll continue getting out of bed in the morning until this life ceases to be anything worth getting up for.

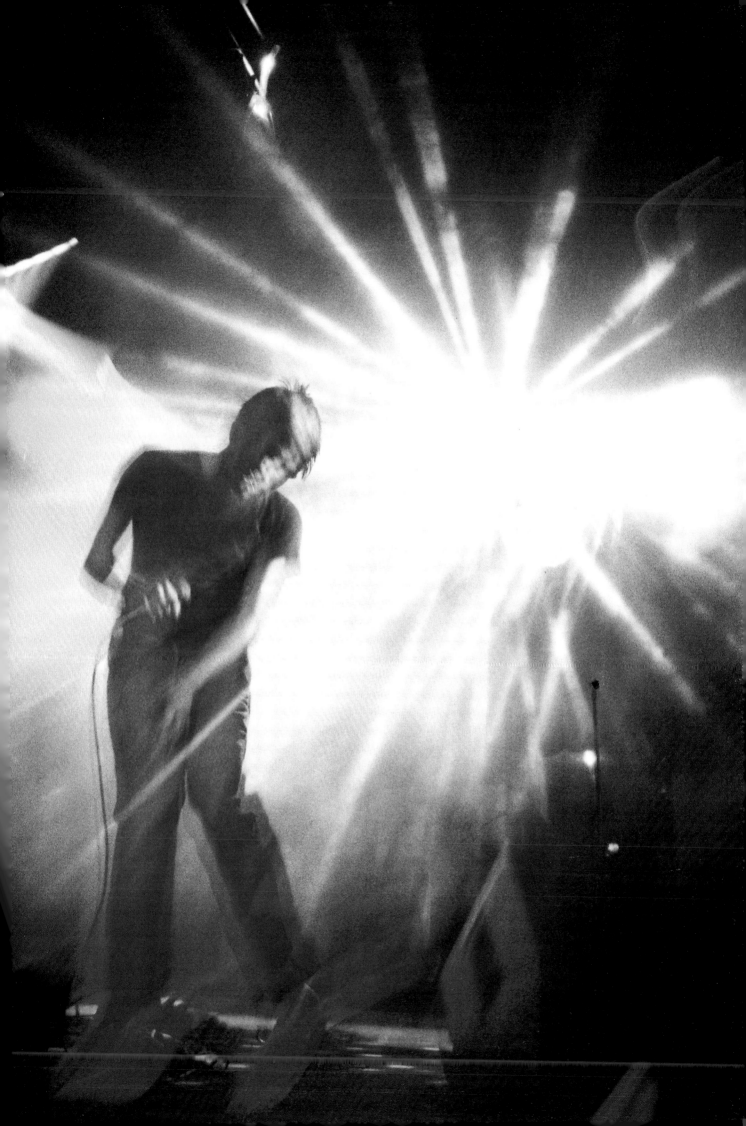

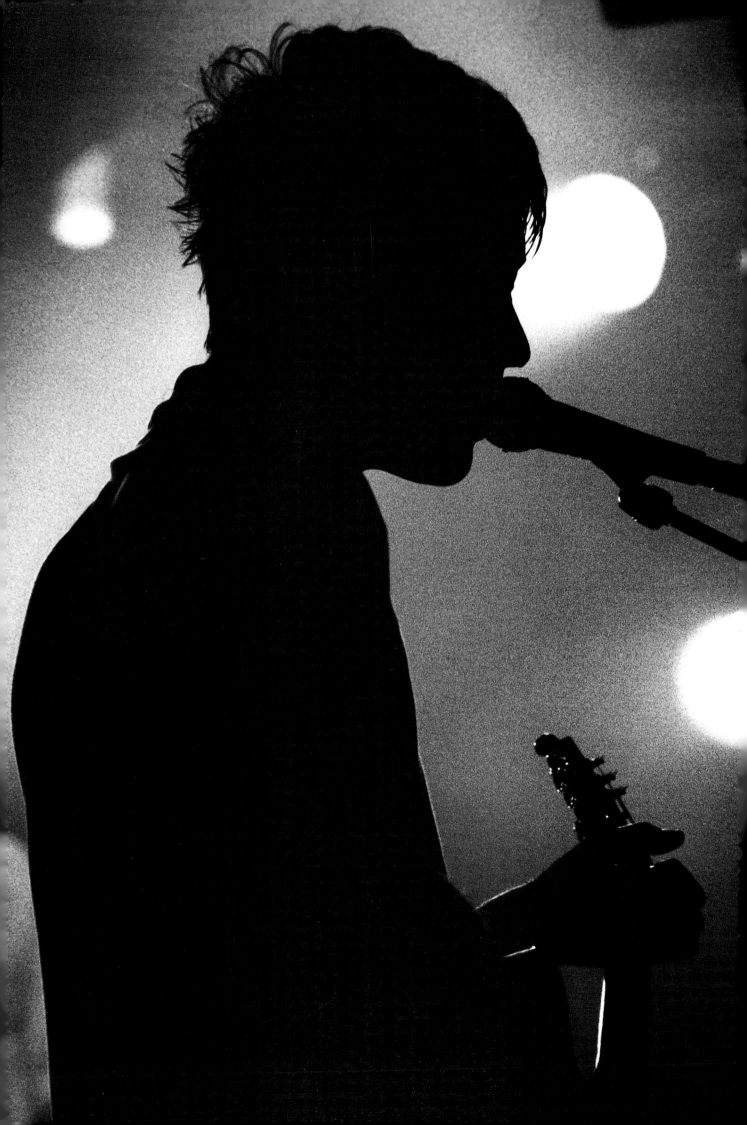

ALEX: What you've got to do is look in your cupboard,
see what's there, put it all in a big pot, sprinkle
some grated cheese on top and bung it in the
oven. That's what pop music is all about.

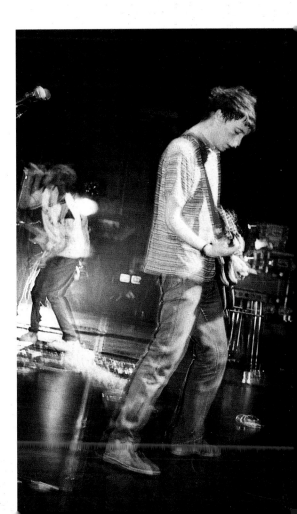

ALEX: The interesting thing with the crash-ride cymbal is it's perfectly positioned for the Mecca Effect where you can't tell whether it's going away from you or towards you.

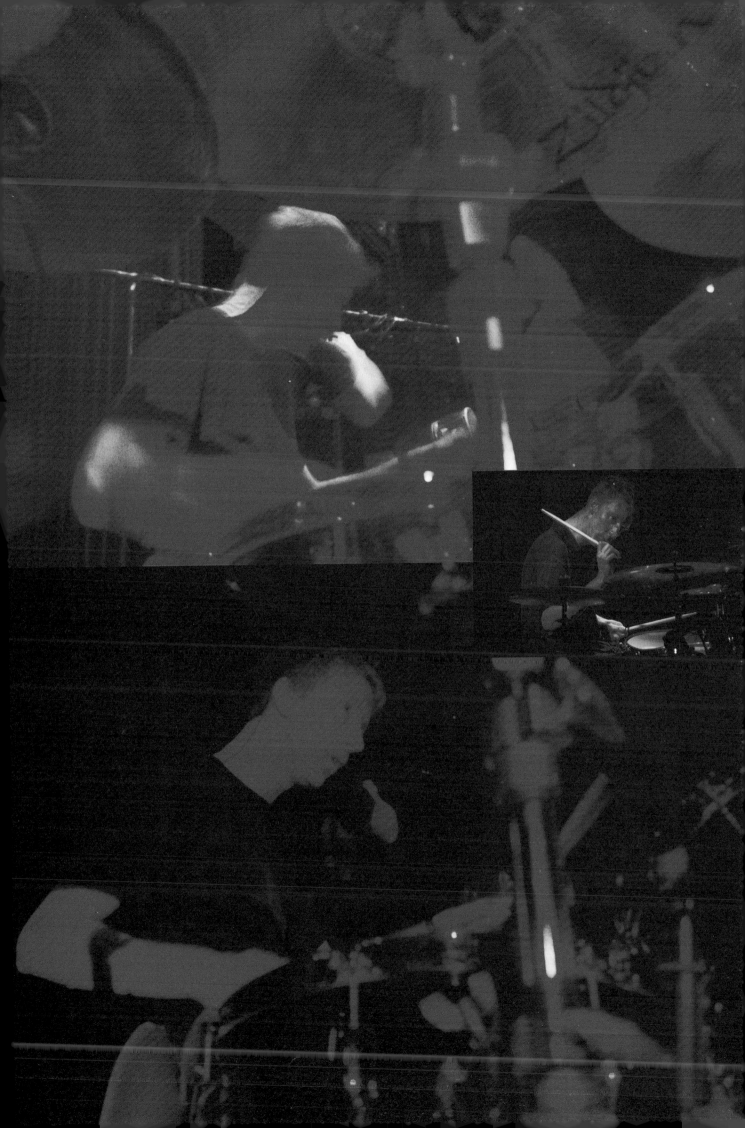

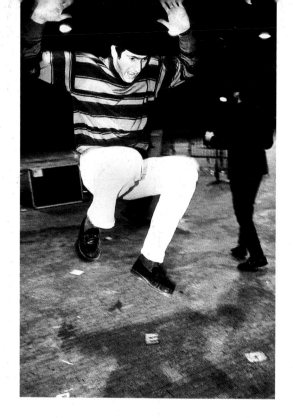

DAMON: Andy the DJ.
Postman from Watford.
Good bloke.

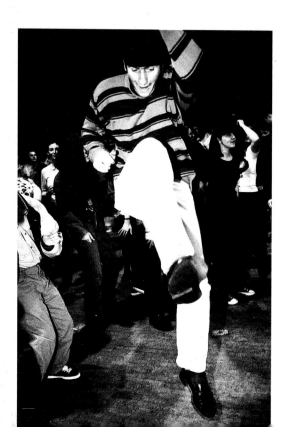

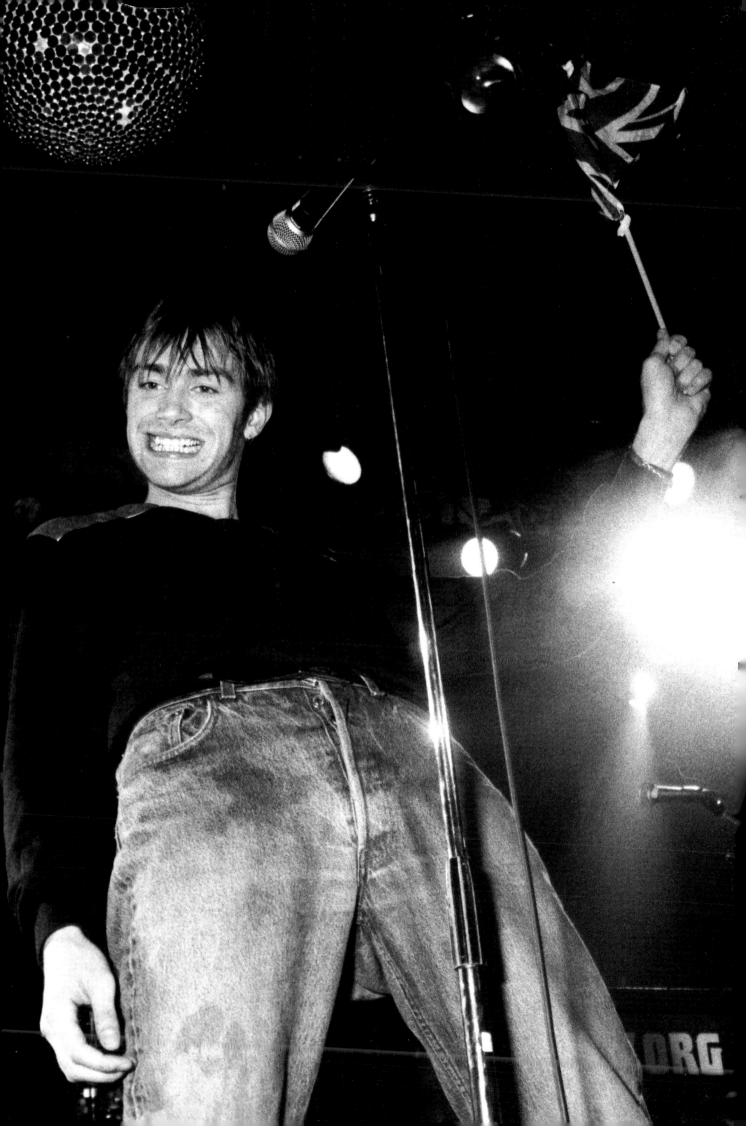

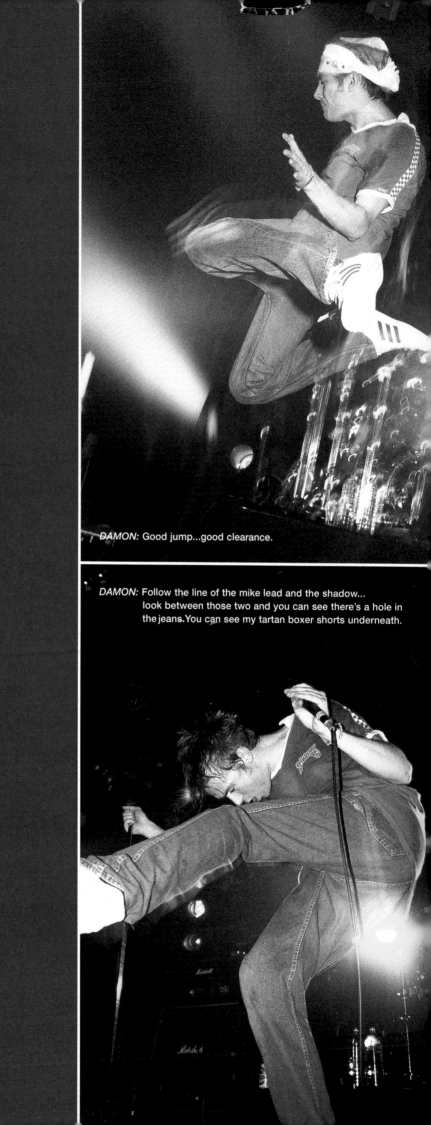

DAMON: Good jump...good clearance.

DAMON: Follow the line of the mike lead and the shadow...
look between those two and you can see there's a hole in
the jeans. You can see my tartan boxer shorts underneath.

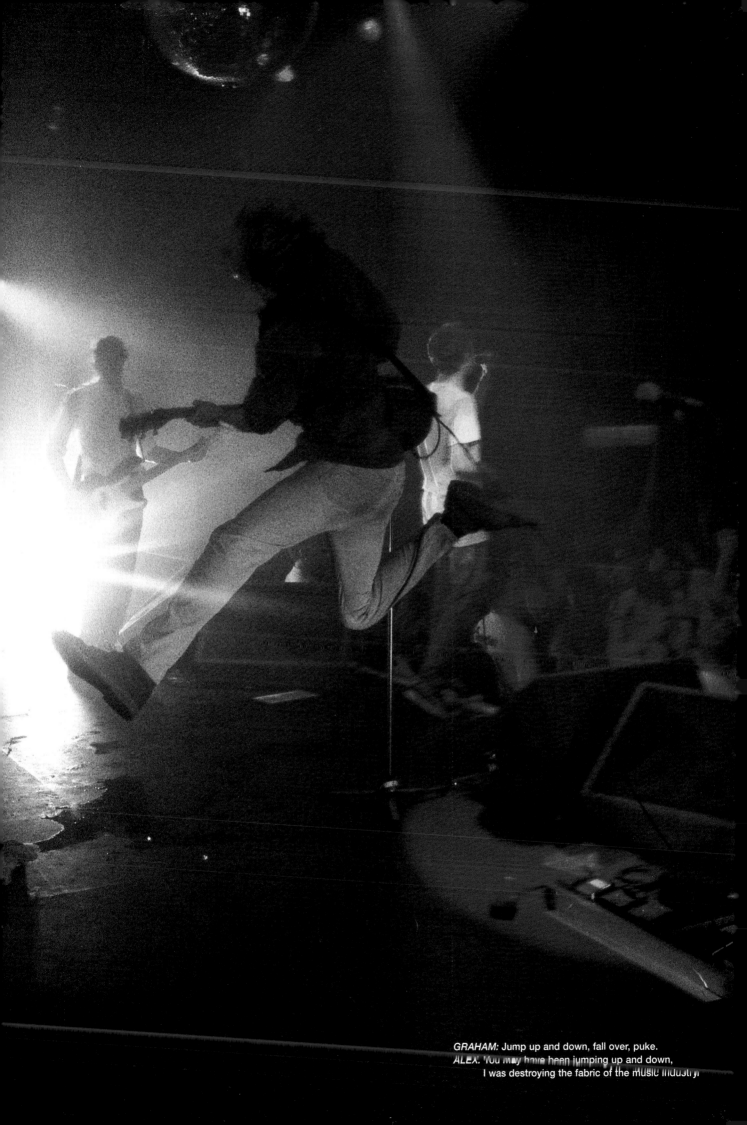

GRAHAM: Jump up and down, fall over, puke.
ALEX: You may have been jumping up and down,
I was destroying the fabric of the music industry!

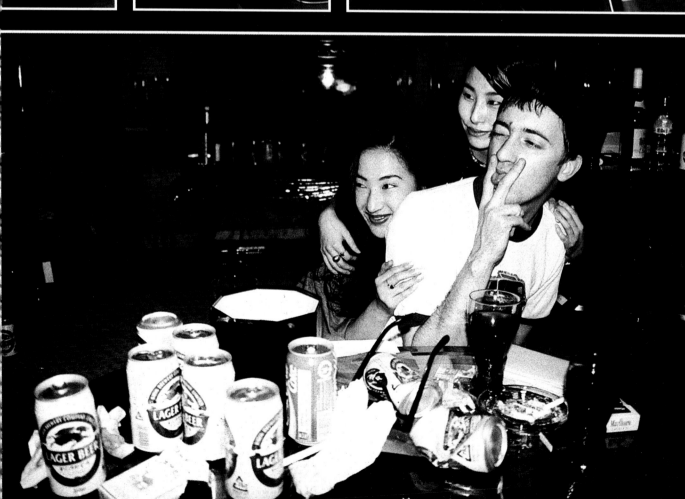

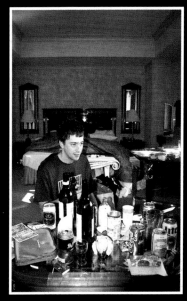

GRAHAM: Is that Club Graham?

 We don't want *that* going in anywhere.

DAMON: Yes we do.

GRAHAM: No we don't.

DAMON: Don't deny what you are Graham,

 that doesn't need editing at all.

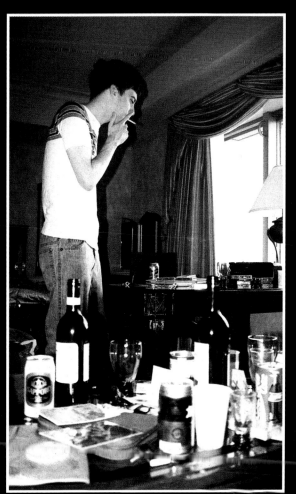

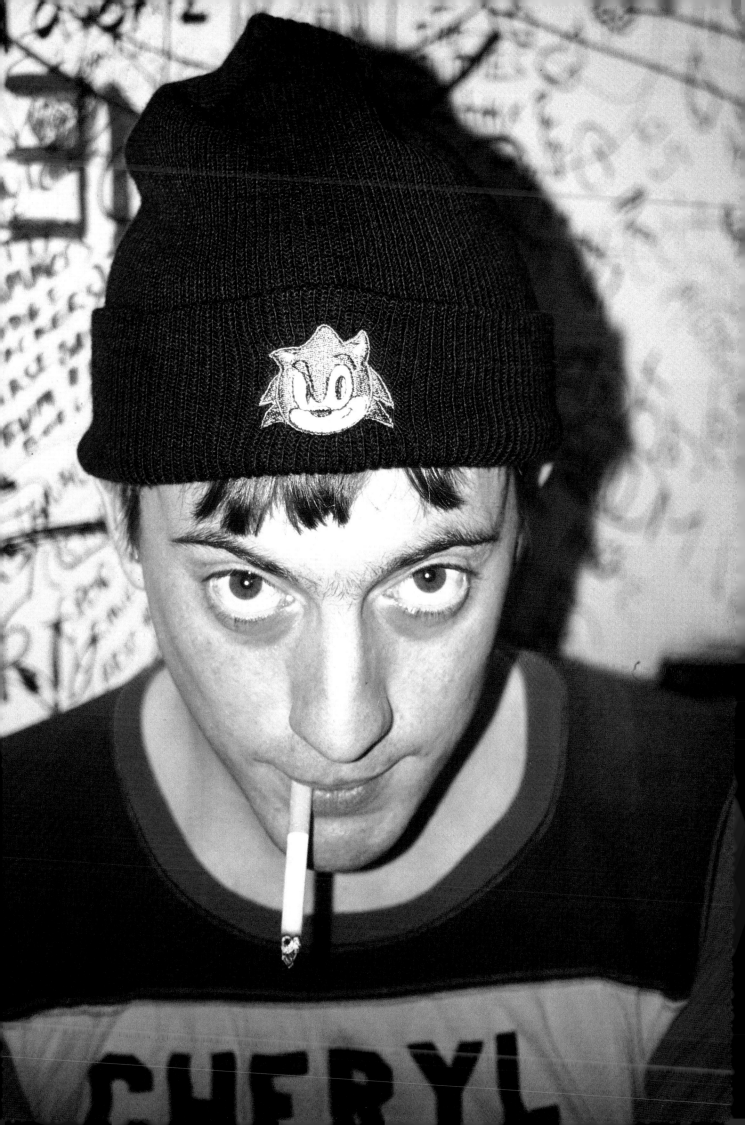

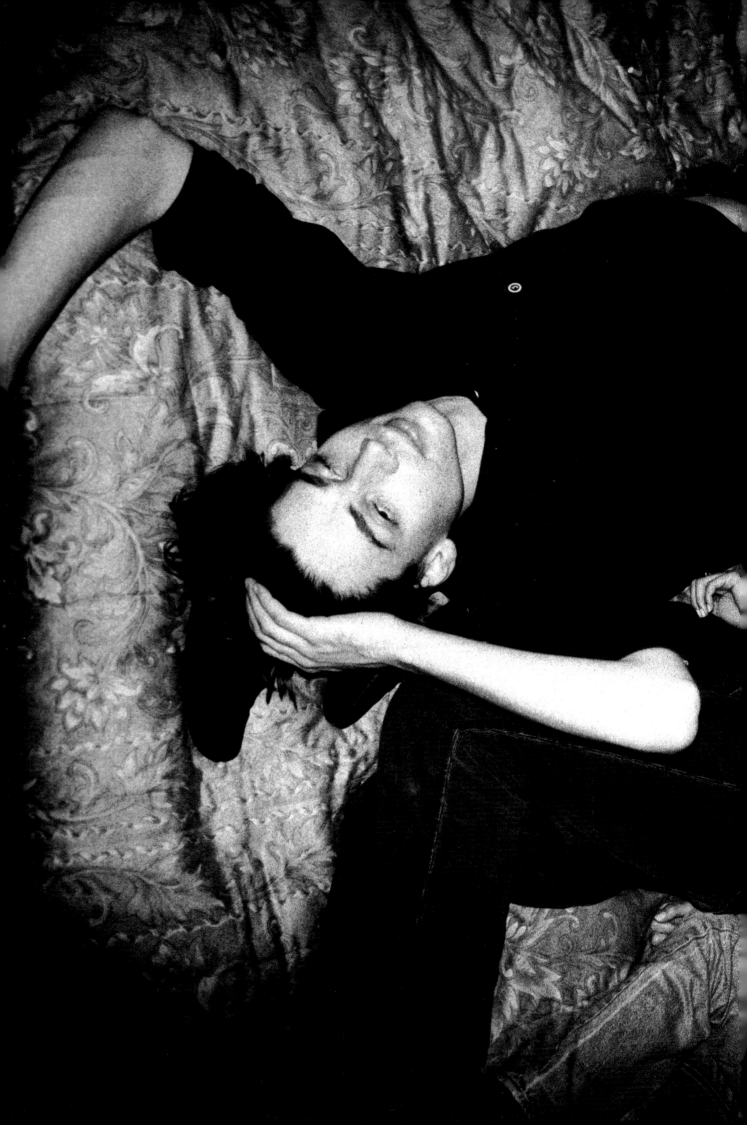

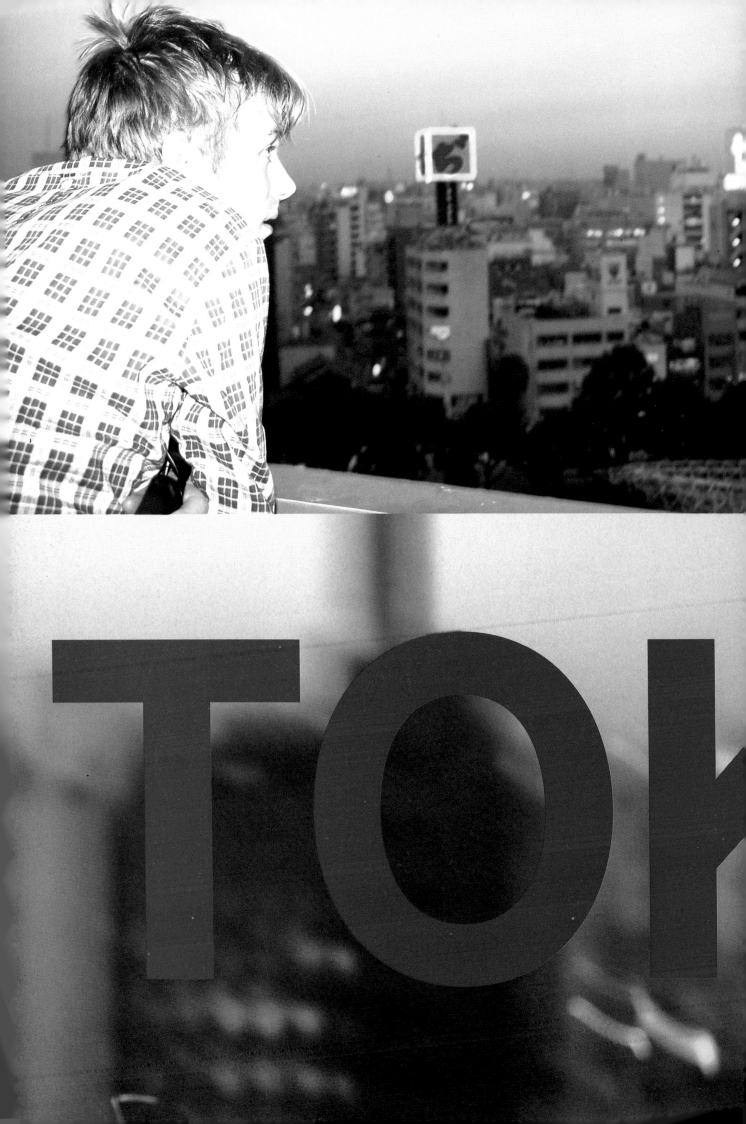

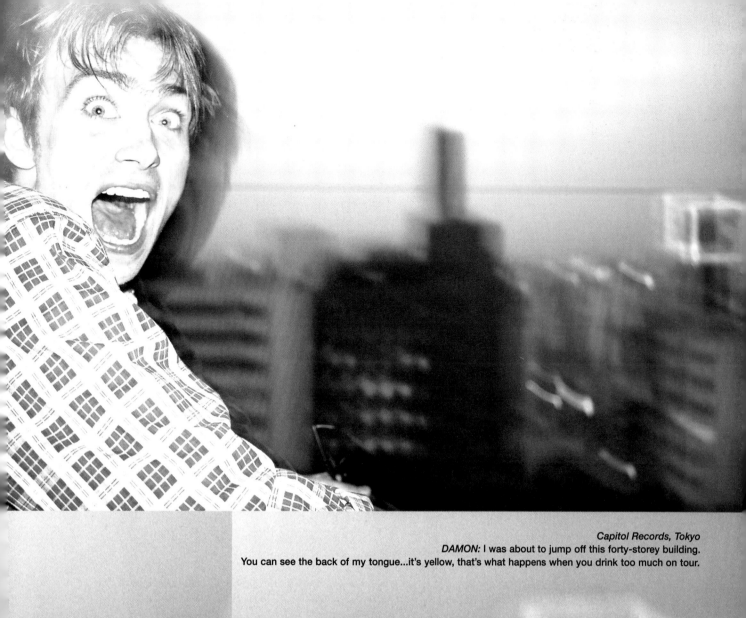

Capitol Records, Tokyo
DAMON: I was about to jump off this forty-storey building.
You can see the back of my tongue...it's yellow, that's what happens when you drink too much on tour.

とびだしきけん

寄贈

DAMON: Graham's exactly the same now as when I first met him. He looks the same and cares about the same things.

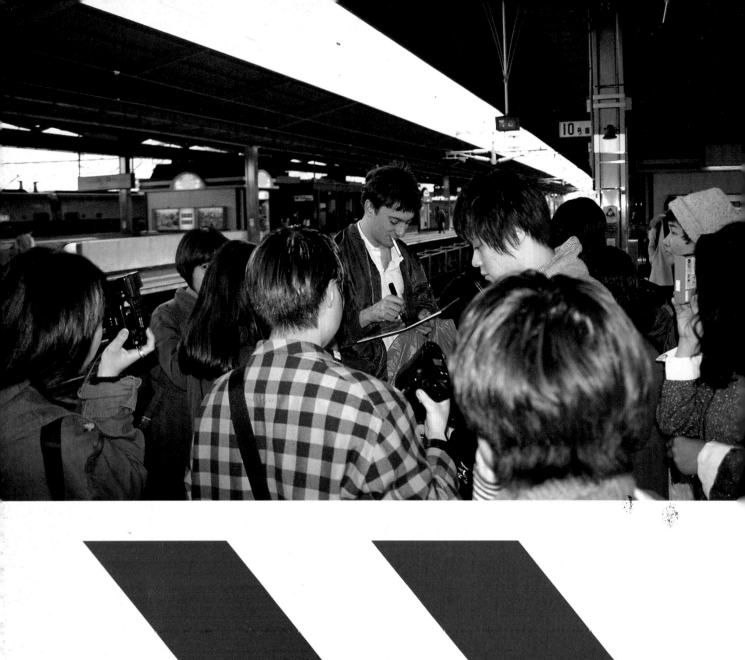

ALEX: Japan...It's nice to be the tallest person for 6000 miles...it's the only place where everyone wears dark glasses.

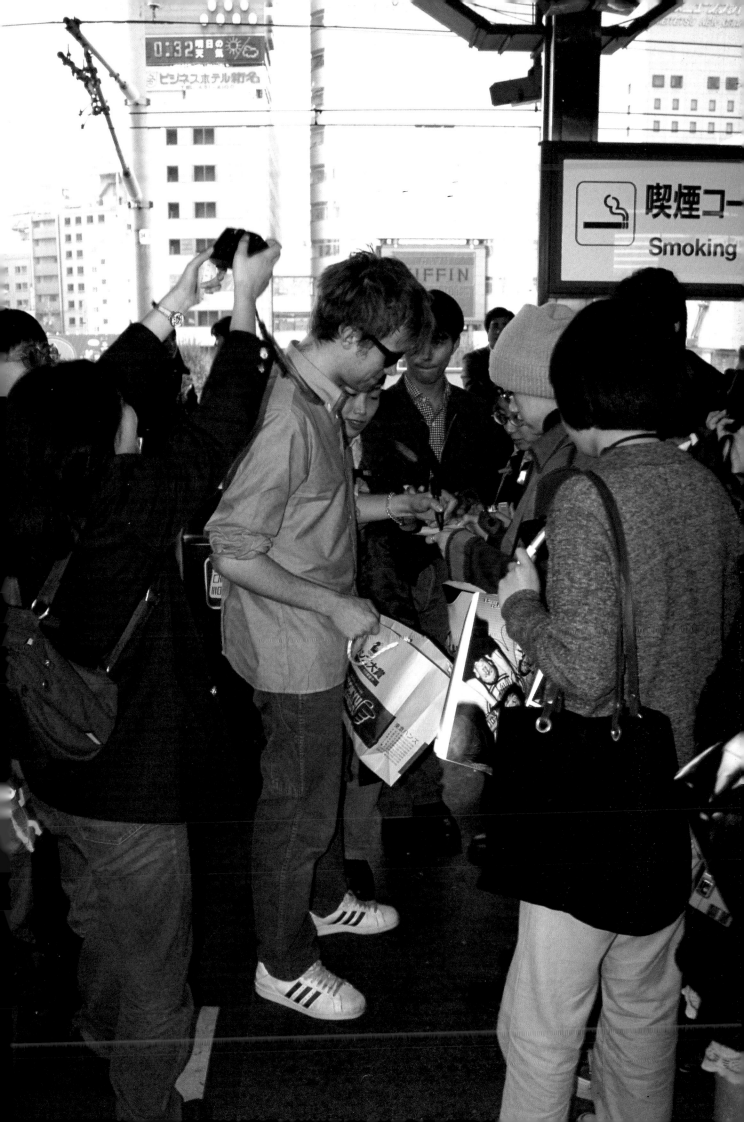

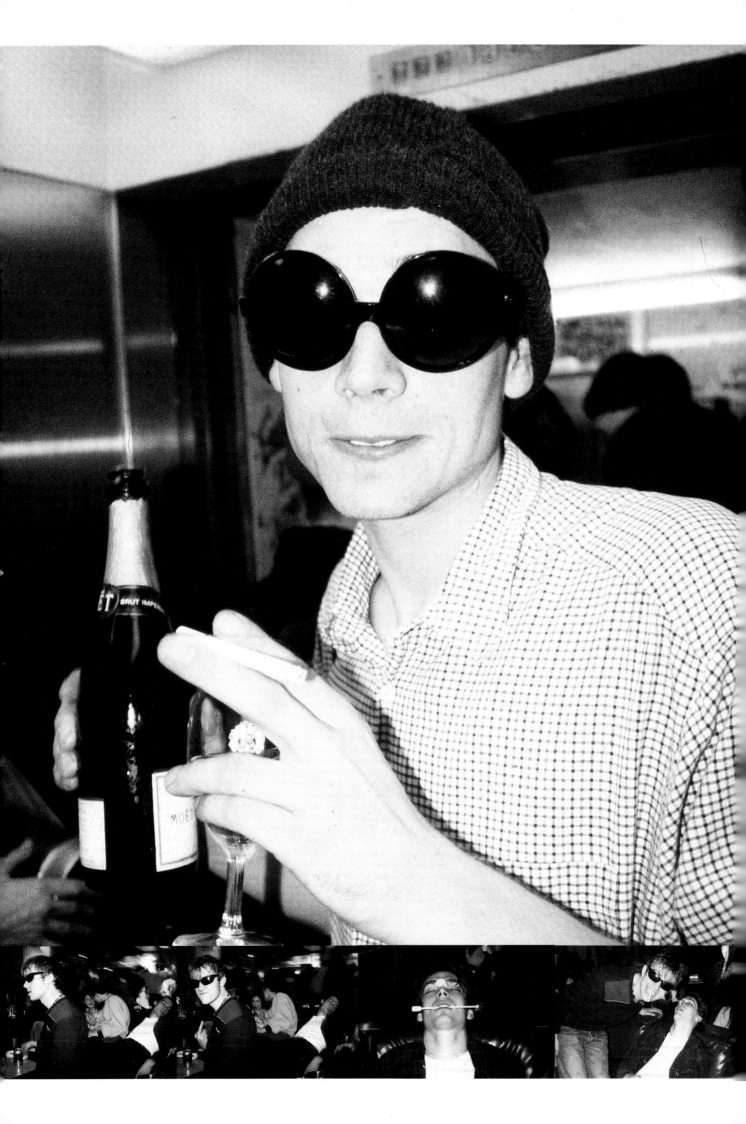

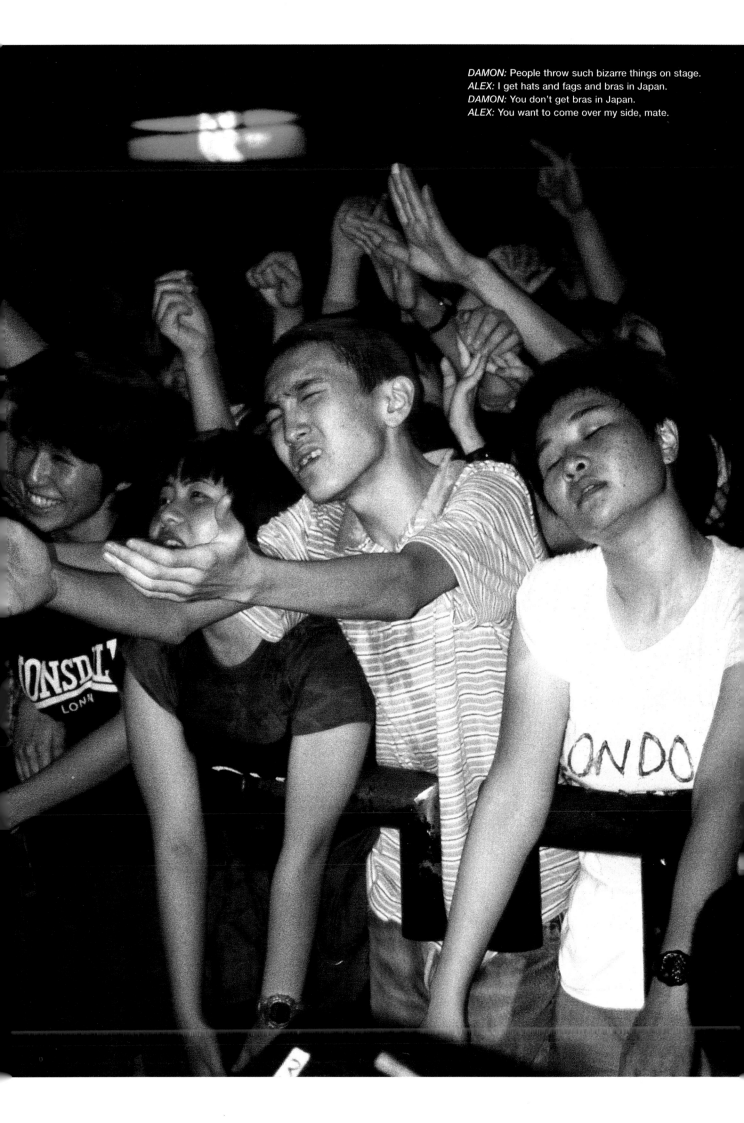

DAMON: People throw such bizarre things on stage.
ALEX: I get hats and fags and bras in Japan.
DAMON: You don't get bras in Japan.
ALEX: You want to come over my side, mate.

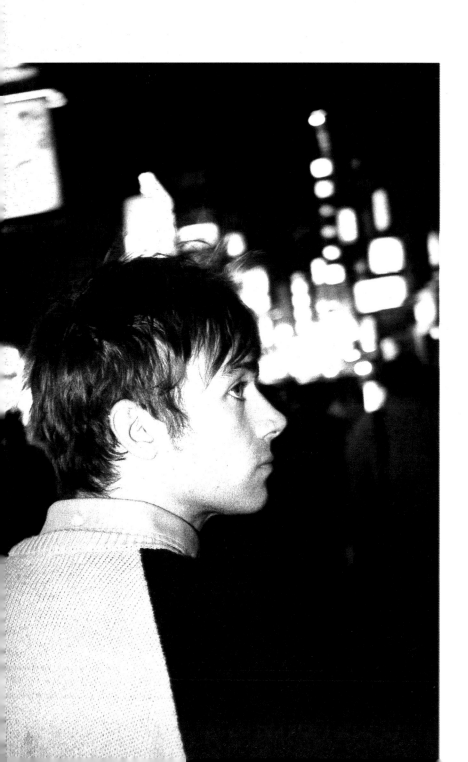

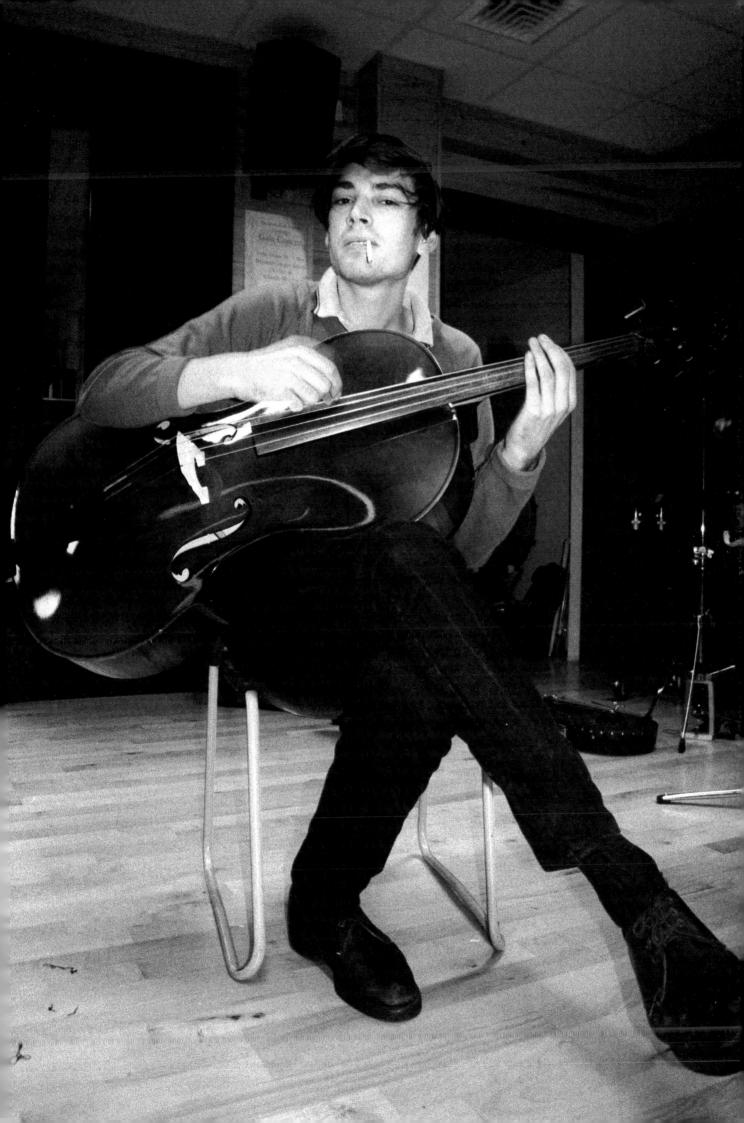

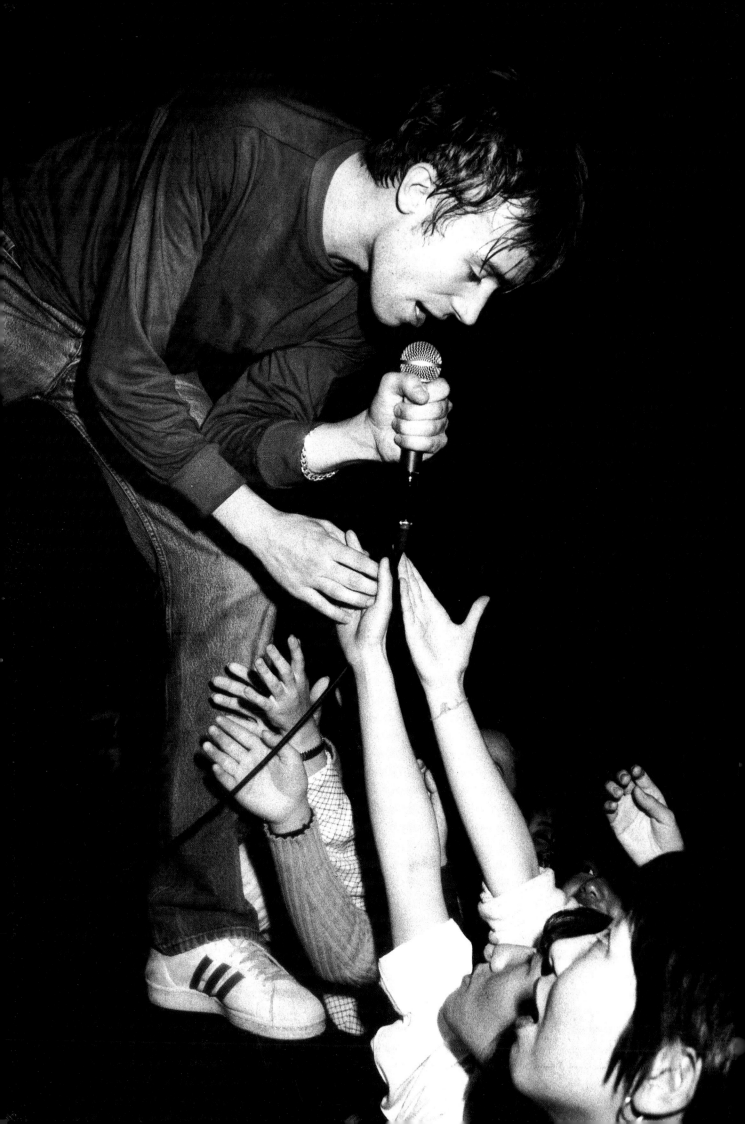

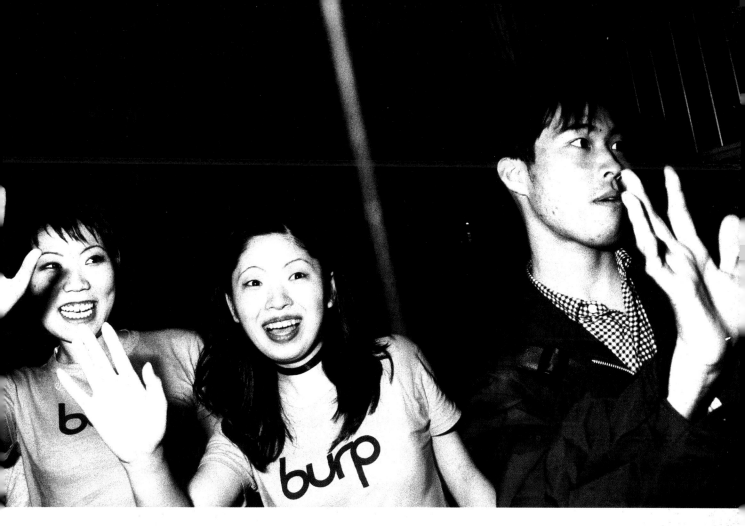

DAMON: In Japan you don't just grab people's hands you kind of squeeze them.

DAMON: British teenagers are basically Mods. It's being a rebel without dropping out of society. The whole idea of Ultra-Normality. Dressing smarter than city gents. That's what I want Blur to be - Ultra-Normal, very normal but still glamorous.

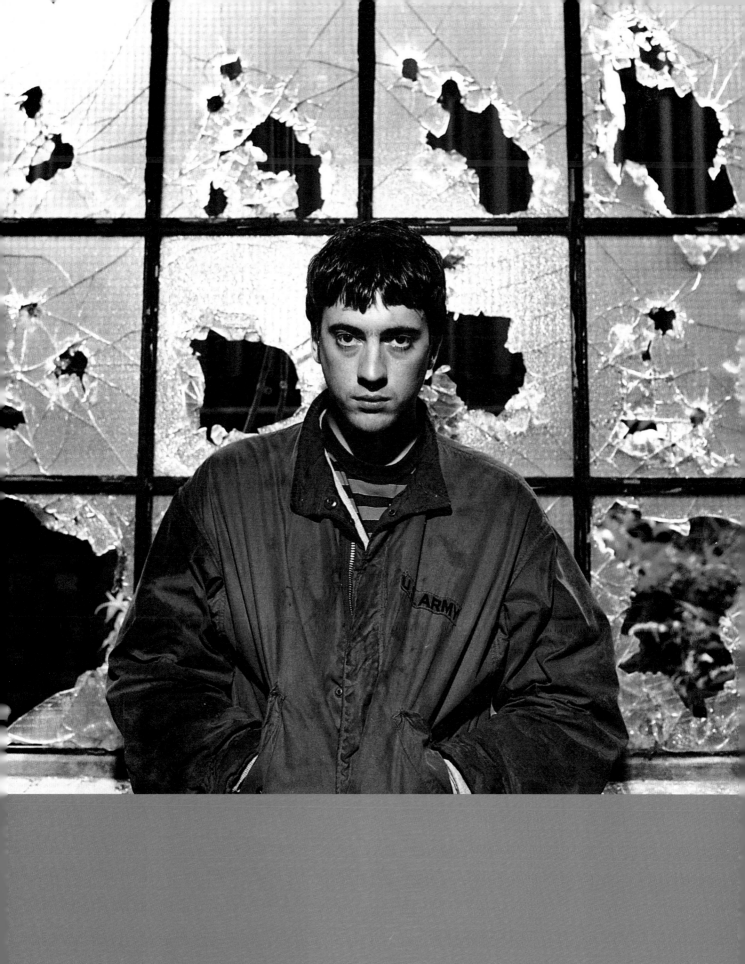

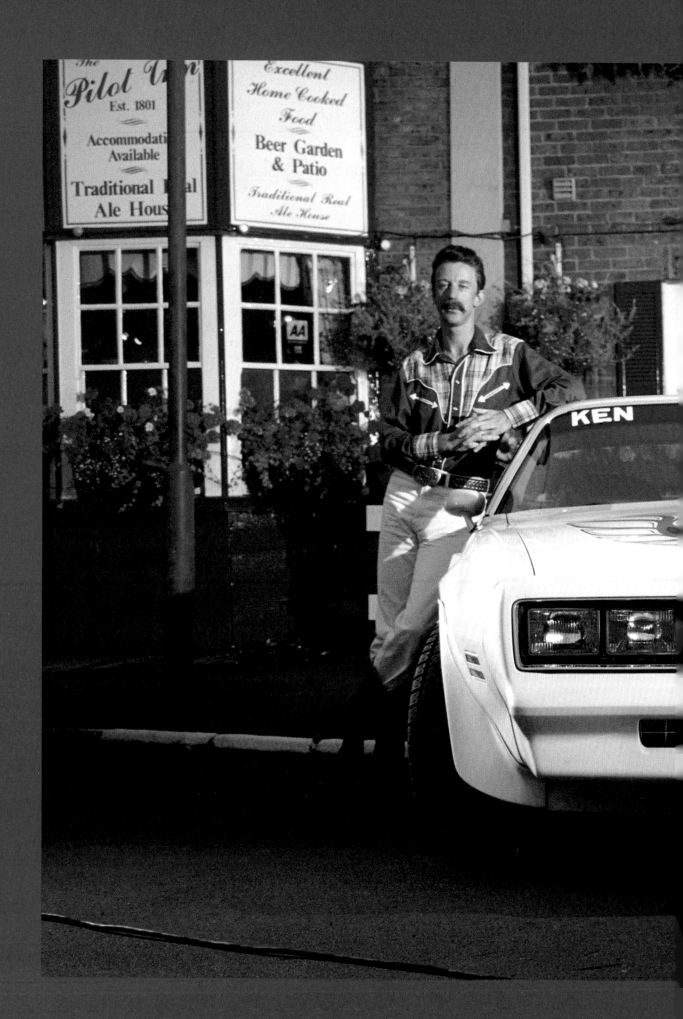

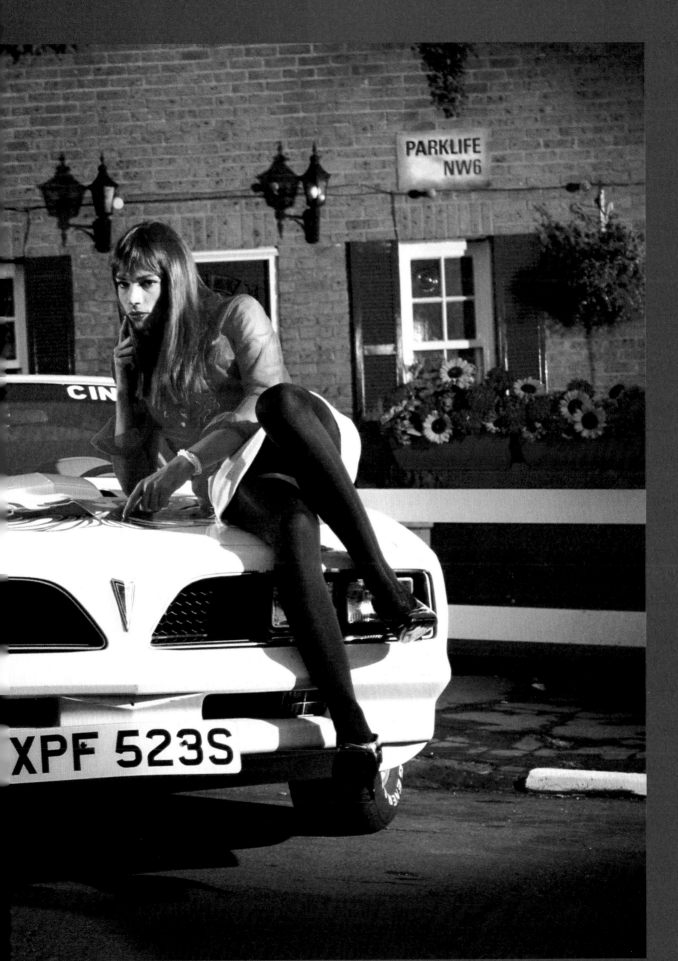

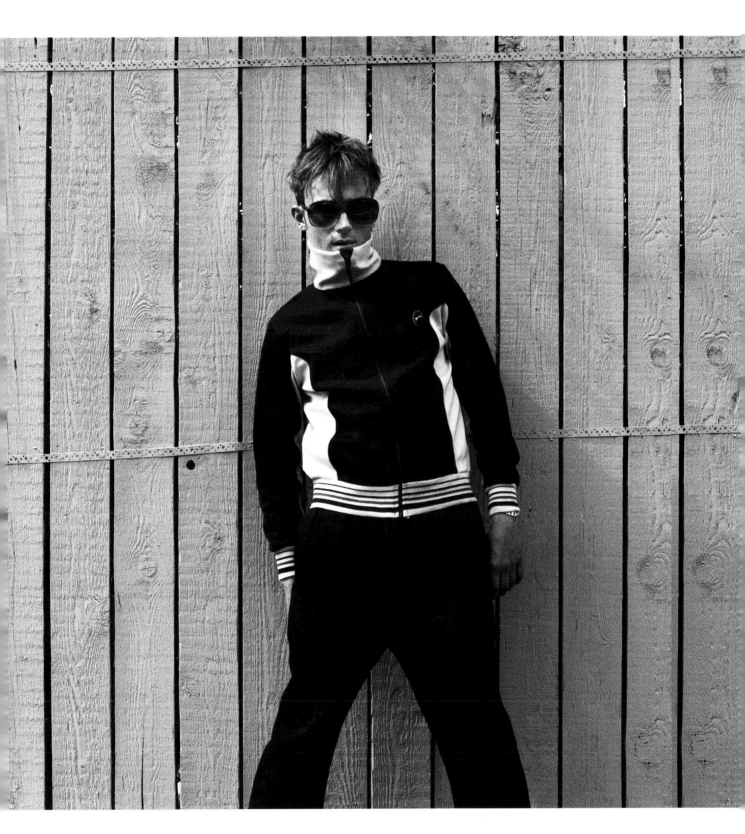

DAMON: My ego is the worst thing about me.

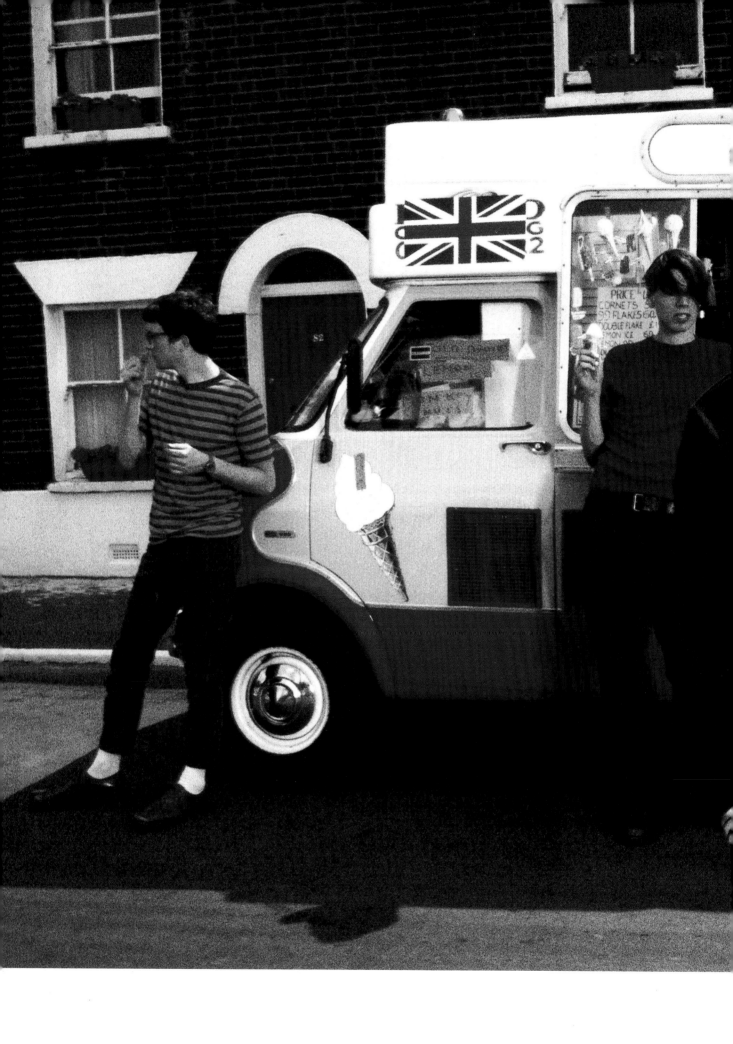

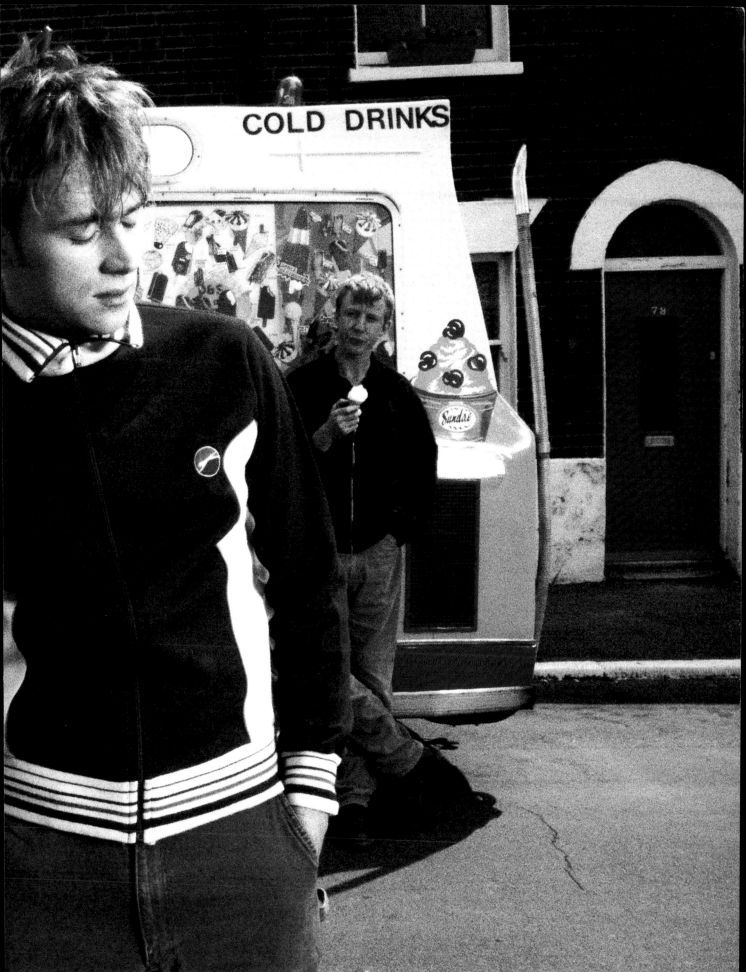

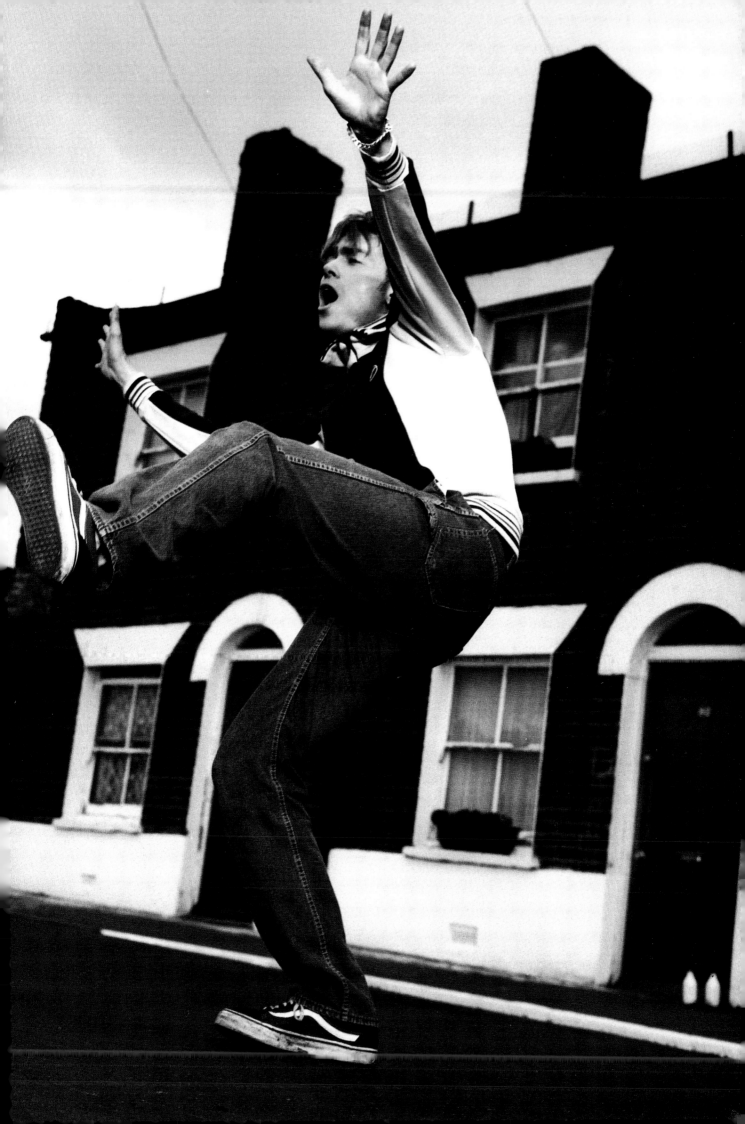

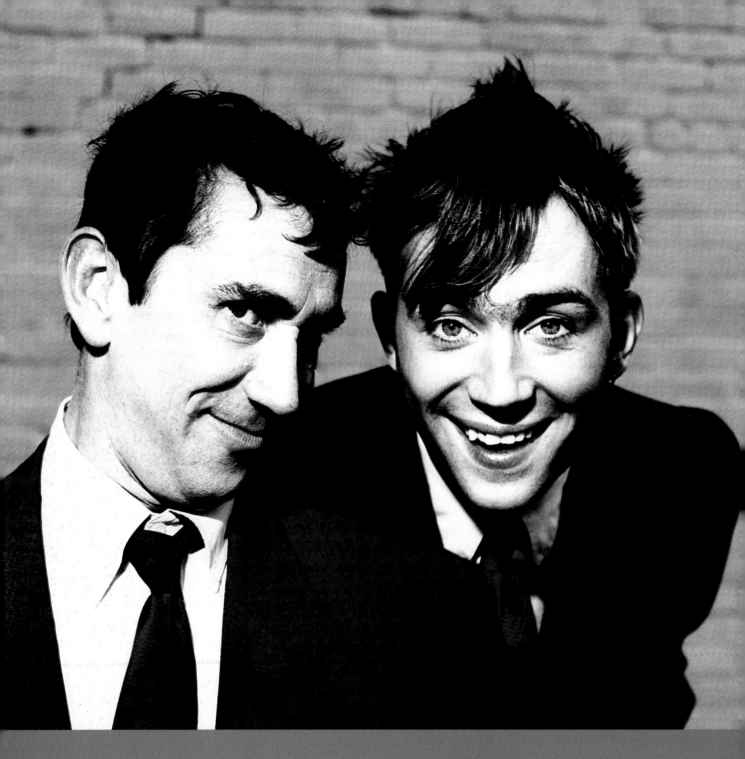

PHIL DANIELS ON PHIL DANIELS: The Bernard Cribbins of this generation.

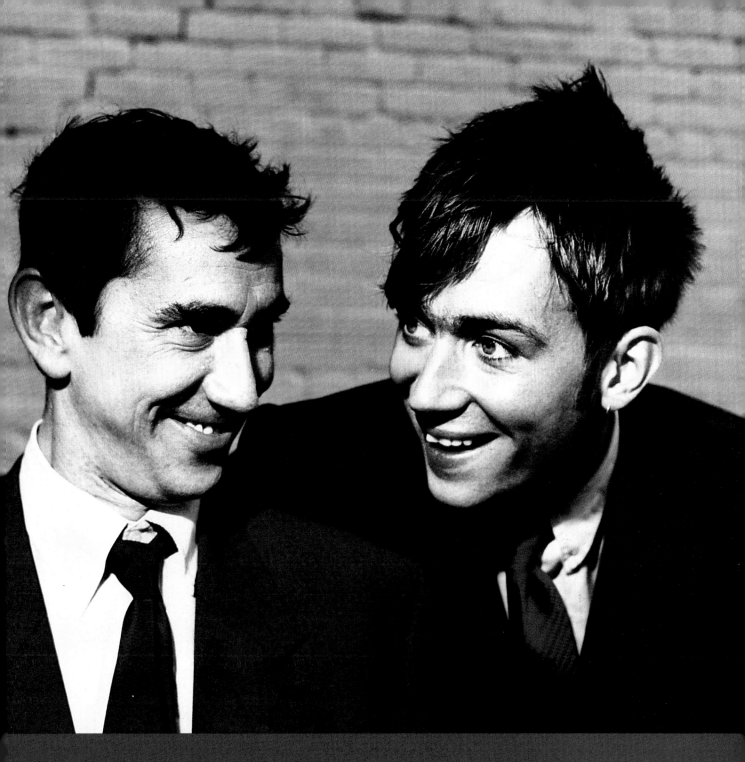

PHIL DANIELS: I shan't be having a pudding. I've never been a big one for Spotted Dick.

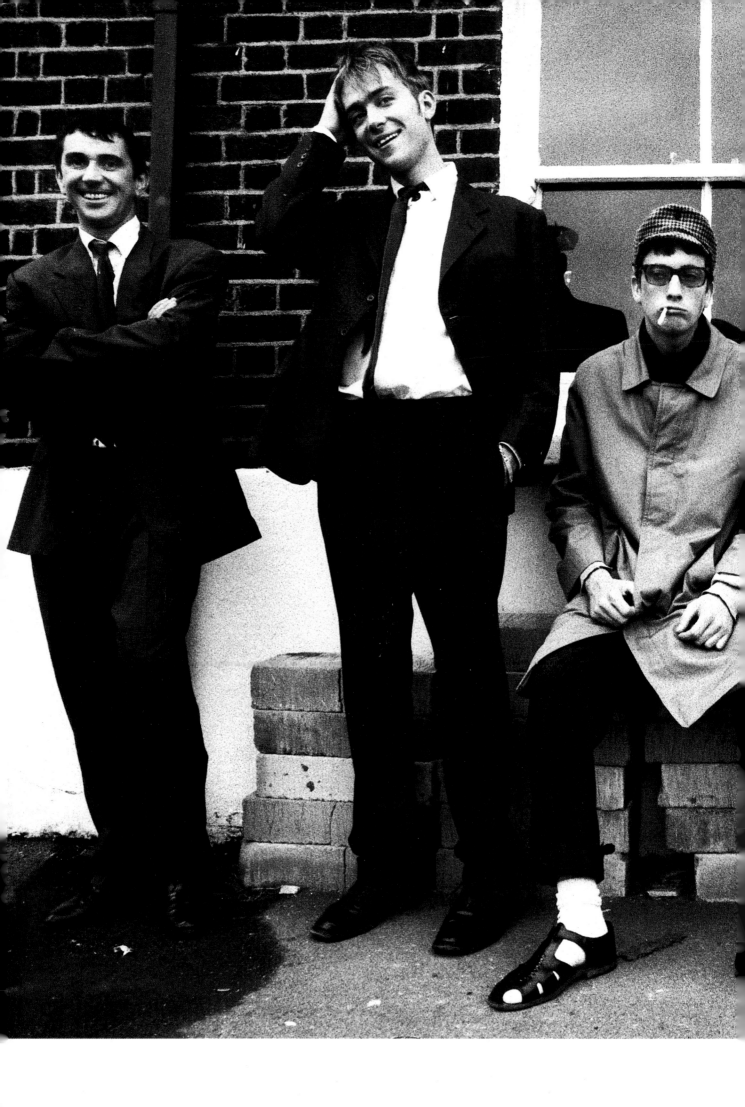

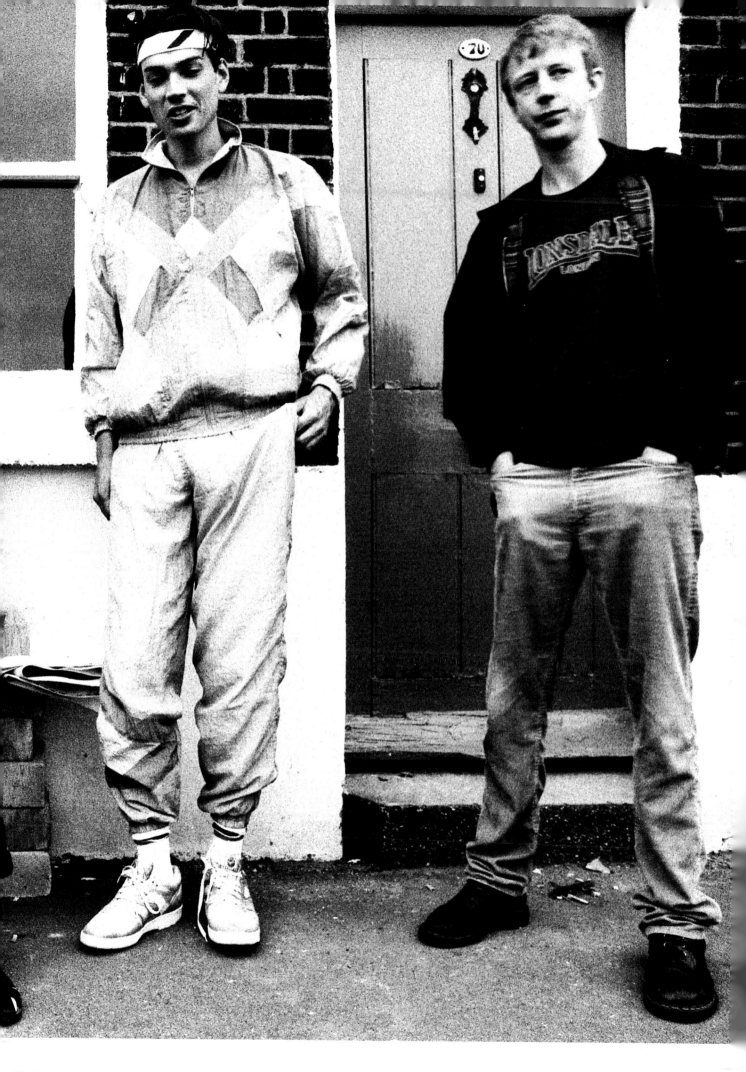

ALEX: We've always been too friendly, too clever and too good looking for a lot of people.

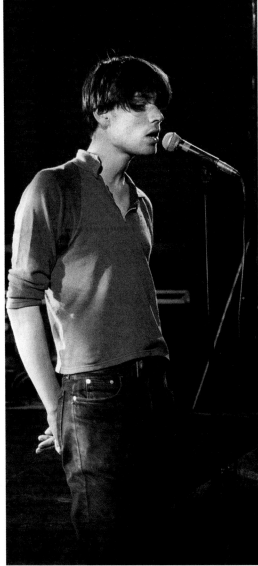
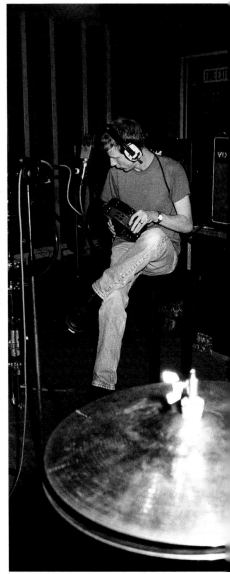

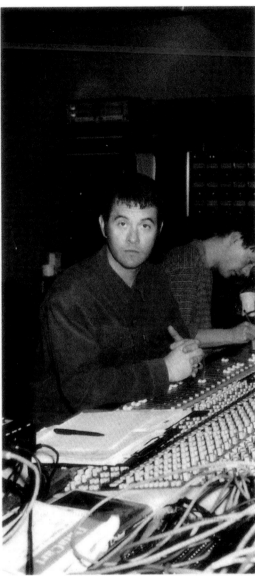

STEPHEN STREET, PRODUCER.
RECORDING '*THE GREAT ESCAPE*'. FEB-JUNE 1995.

JUNE 15TH 1995 *Exeter University Ball.*

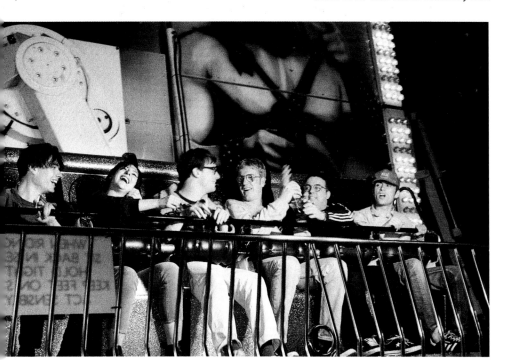

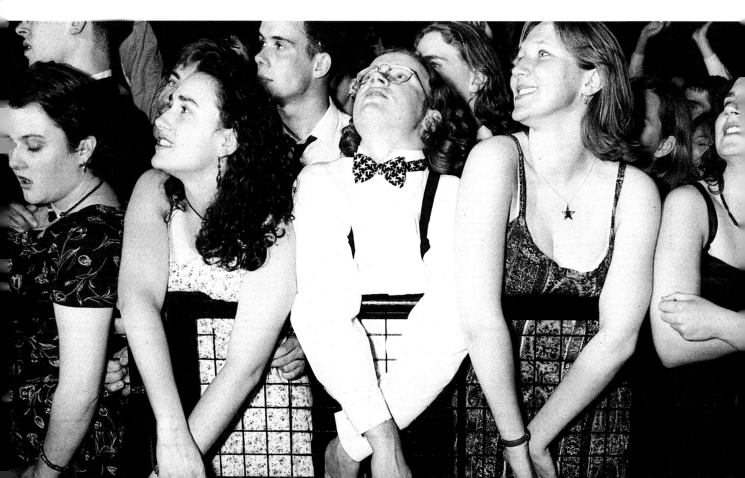

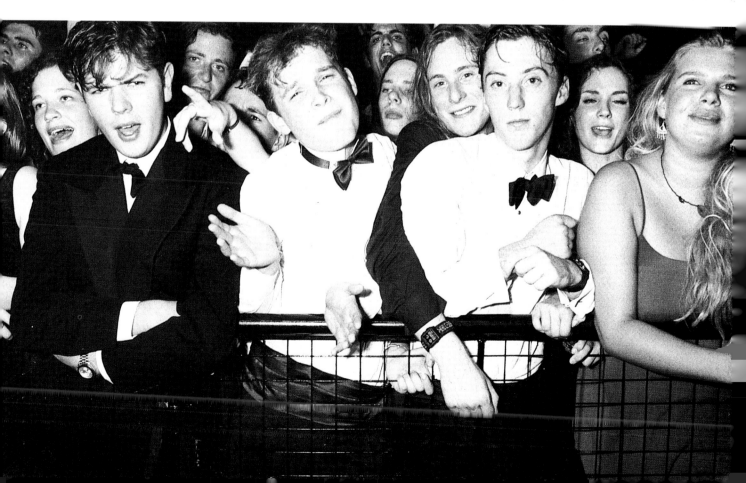

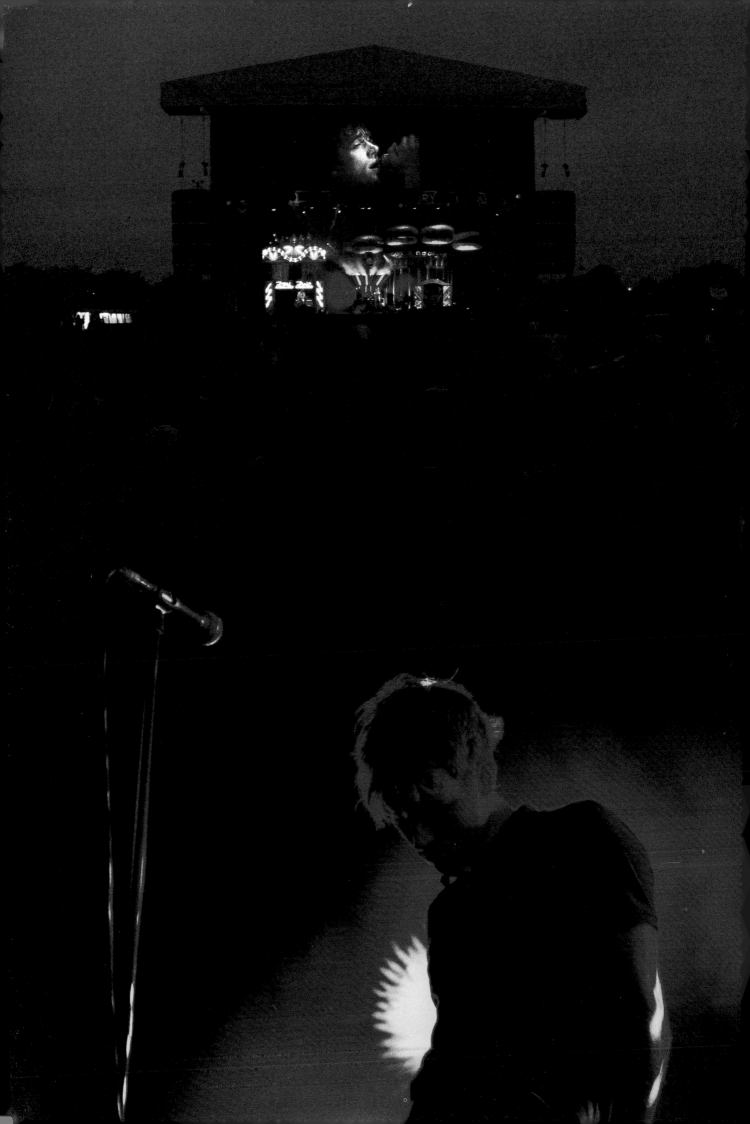

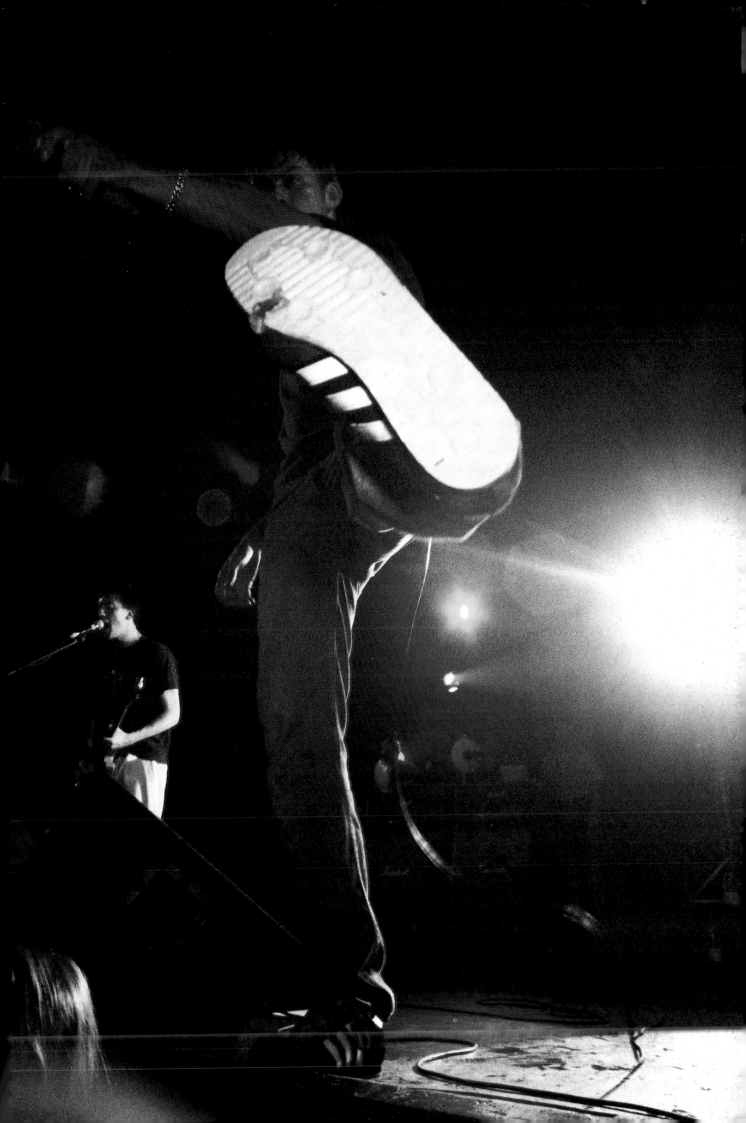

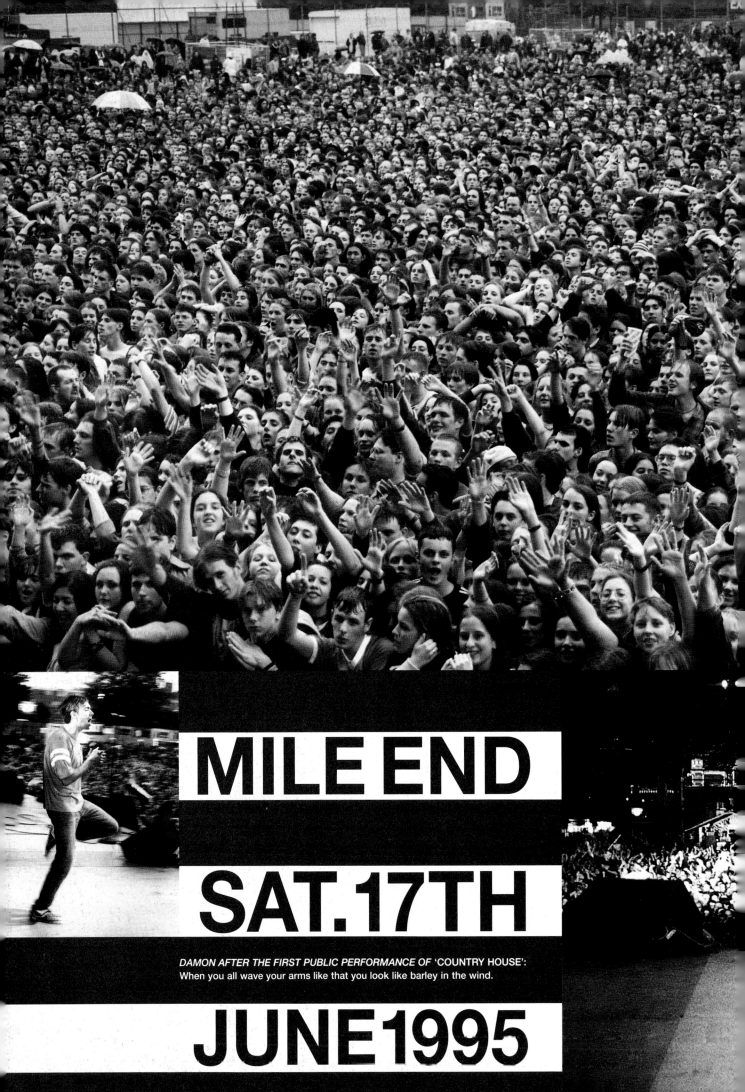

MILE END

SAT.17TH

DAMON AFTER THE FIRST PUBLIC PERFORMANCE OF 'COUNTRY HOUSE':
When you all wave your arms like that you look like barley in the wind.

JUNE 1995

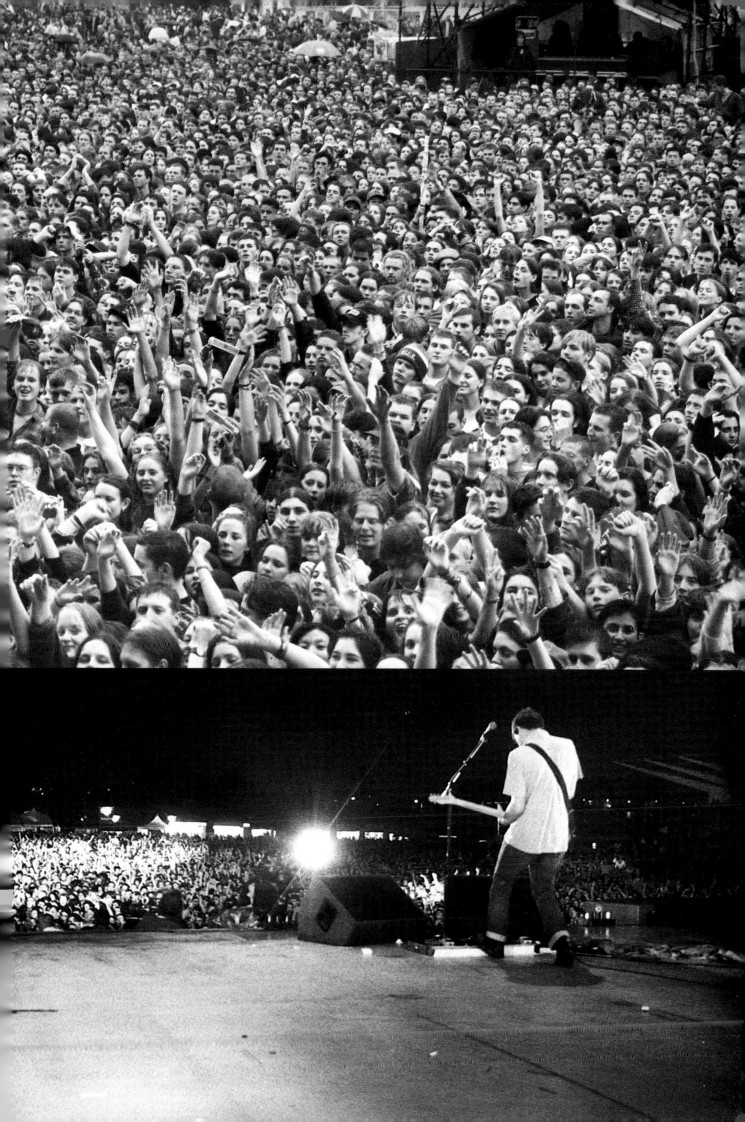

THE END